Dare to sketch
A guide to drawing on the go

Felix Scheinberger

Dare to sketch

A guide to drawing on the go

WATSON·GUPTILL

CALIFORNIA | NEW YORK

Contents

 Foreword

 The sketchbook

 A book with personality

 Tools

 Expressing yourself

 The basics

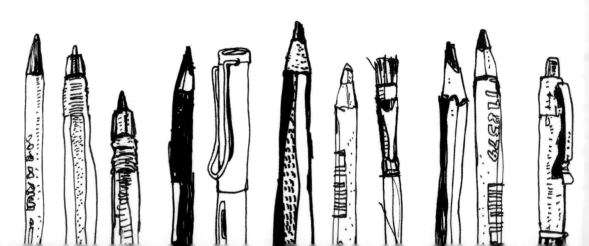

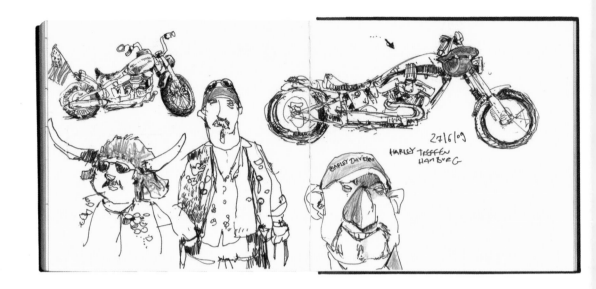

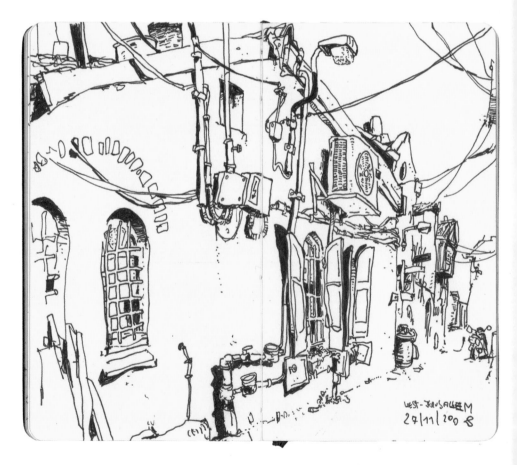

Why use a sketchbook?

The entry of digital media into all spheres of design and artistic work has narrowed the world of designers, artists, and illustrators to a very small space: our desks. The consequence of this is that we lose a little of our contact with the outside world. We sit at the computer and when we want to draw a subject from outside, we simply google it.

The book you are holding is an attempt at something else. First of all, it contains instructions for drawing and sketching. It deals with the basics and tips and especially the fun of sketching. In addition, this book aims to convey that drawing is a medium that opens up new and larger spaces: spaces in our inner world and in the outside world. Drawing encompasses imagination and knowledge and is one of the few artistic fields in which we experience our subjects on location firsthand. By drawing things, we reflect reality anew. We are no longer processing someone else's images, but going out into the world and looking at it with our own eyes. A sketchbook enables us to enhance our perspective and thereby enhance our world.

In addition, there is something authentic and personal about drawings. If we only google subjects, we are faced with the problem that we are all using the same images, narrowing our view of the world through the hierarchic funneling process of search engines.

We are presently experiencing a tremendous renaissance in drawing. The genuine is in demand. The vast possibilities of image processing have damaged the credibility of photography. Drawings are enjoying a boom because they are authentic. We artists vouch for our drawings. By doing and experiencing it ourselves, we personally guarantee the authenticity of our pictures. The obvious subjectivity and intimacy of drawn pictures make the medium paradoxically more "real" than photographs or googled images. This means that drawings also are gaining documentary relevance—which leads us to the sketchbook.

My sketchbook is something very personal. I draw in it for me and not for others; I use it to describe my world and my life. I am interested in the world I live in, and in a conscious and prolonged process that lasts longer than that of taking a snapshot. I deal with the world. Drawing is also a sensual process: we draw people differently when we associate an odor with them. A meal that we draw will look different if it doesn't taste good, and we will draw our own dog differently than some unknown animal.

A sketchbook is just the right place to implement these impressions: it is a personal, human medium. And therein lies its gains—for us, as well as for art. In order to reap our own experiences we have to walk out the door. And when we walk out the door, it's good to take a sketchbook along.

Yours truly,

Which sketchbook?

To be honest, you won't make better drawings just because you purchase a more expensive sketchbook. On the contrary, a valuable book will probably leave you afraid to make mistakes in it. Mistakes are part of the whole process.

That said, you ought to pay attention to a few things when buying a sketchbook:

- Use *acid-free* paper. Paper is often bleached with acid. This is not only damaging to the environment, but also to your book in the long term. A little acid always remains in the paper during production and this will break it down over the years. Take a look at a cheap paperback from the sixties: the paper crumbles.

- It is also important that your book is *hardbound.* Don't use a wire-bound sketchpad. This binding style has a gap in the middle and you won't be able to make double-page images.

- In addition, the pages should be sewn and not glued so they do not tear out.

- A decent sketchbook needn't cost more than ten dollars.

Tip:
First of all, write your name and your address in your new sketchbook. If you should ever lose it, you'll have a chance of getting it back.

Tip:
If you choose a book with thicker
acid-free paper, you'll also be able
to paint with ink and watercolors.

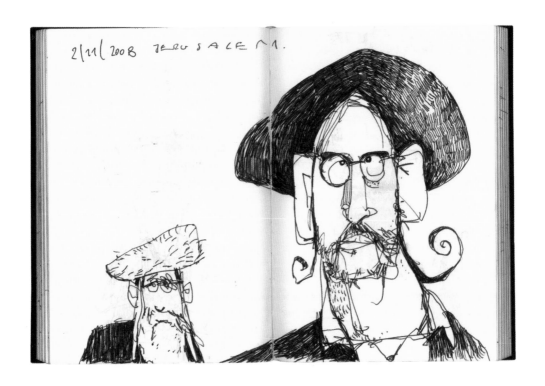

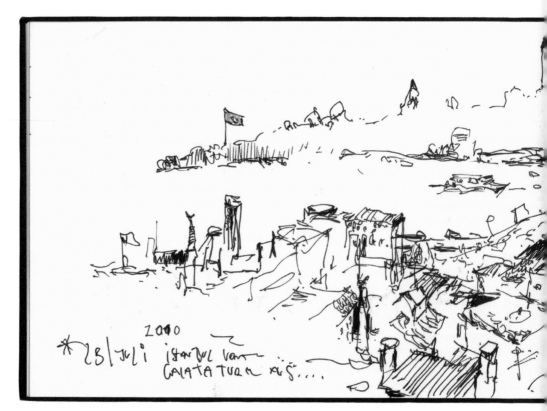

Choosing a format

The format of your sketchbook (large or small, landscape or portrait) is up to you. But I can tell you which I prefer and give you my opinion on what works best for which size. The terms "landscape" and "portrait" already tell you what each format is best suited for. That said, you can draw a beach scene across a double page in a portrait-sized book, but fitting standing figures in extreme landscape formats is difficult. Landscape formats can be great for traveling, though.

I tend to prefer smaller sketchbooks, like 5 by 7 inches. They are lighter and not as conspicuous as larger options. Hold a few books at the store and let your gut decide which you like best.

Tip:
Test your sketchbook to find out whether ink soaks through the pages. In this Moleskine sketchbook, shown below, the page at left displays (clockwise from top left) watercolor, fineliner pen, India ink, industry painter, ballpoint pen, Edding marker, sepia ink, and marker. Notice how the India ink, sepia ink, and Edding marker have seeped through (right).

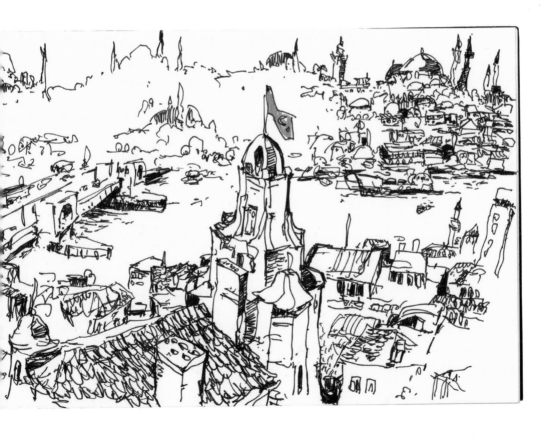

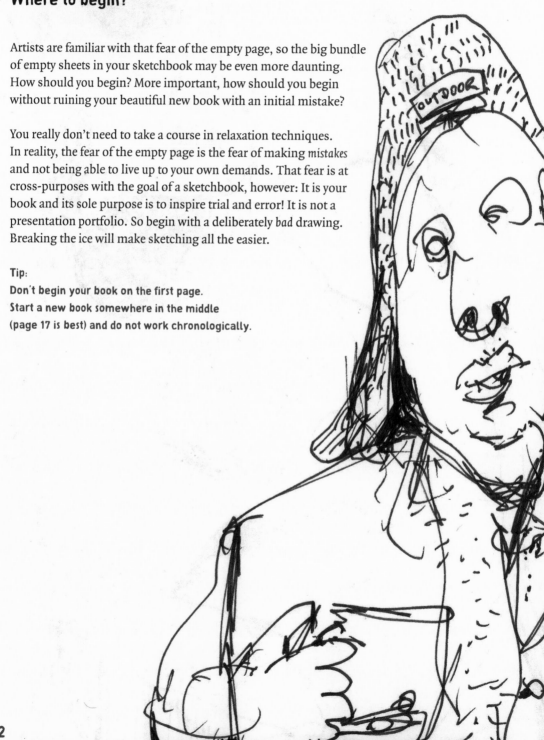

Where to begin?

Artists are familiar with that fear of the empty page, so the big bundle of empty sheets in your sketchbook may be even more daunting. How should you begin? More important, how should you begin without ruining your beautiful new book with an initial mistake?

You really don't need to take a course in relaxation techniques. In reality, the fear of the empty page is the fear of making *mistakes* and not being able to live up to your own demands. That fear is at cross-purposes with the goal of a sketchbook, however: It is your book and its sole purpose is to inspire trial and error! It is not a presentation portfolio. So begin with a deliberately *bad* drawing. Breaking the ice will make sketching all the easier.

Tip:
Don't begin your book on the first page.
Start a new book somewhere in the middle
(page 17 is best) and do not work chronologically.

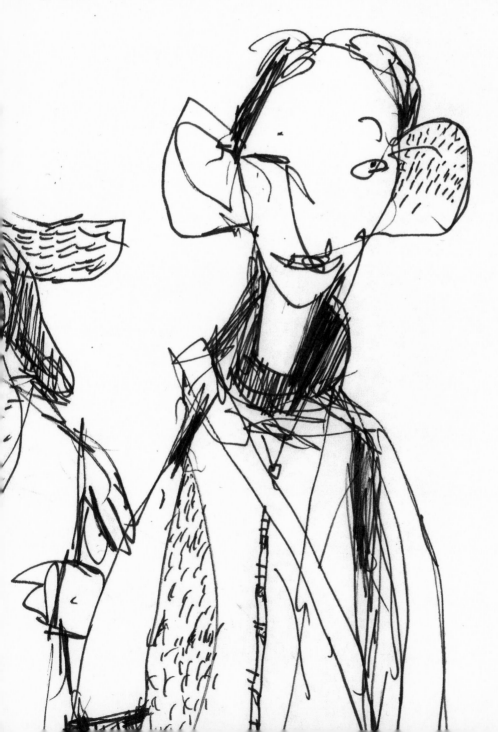

Protecting your sketchbook

There you are, sitting in a café or park. The sun is shining, and you're sipping your coffee and writing notes in a pad. Maybe you're jotting down some ideas, keeping a journal, or writing a postcard. Now imagine some perfect stranger comes along suddenly, stands next to you, and starts reading your words and making comments. He praises your creativity, corrects your spelling errors, and asks who Sally and Frank are. You'd be flabbergasted!

And yet, this happens with sketchbooks all the time. There are always people who think they're skilled enough to rate your work and apparently believe that your drawings are their business. Put a stop to it. Protect your sketchbook. Don't be afraid to say no.

It's your sketchbook and yours alone, and should matter to no one else. Once you are aware of this, it becomes a lot easier to work on a sketchbook. You are not drawing for any presumed critics or admirers, but for yourself. You aren't producing a presentation booklet, but a creative space that consciously allows for mistakes and experiments.

Your sketchbook is not a public space. Protect it.

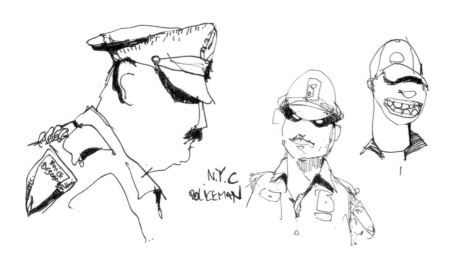

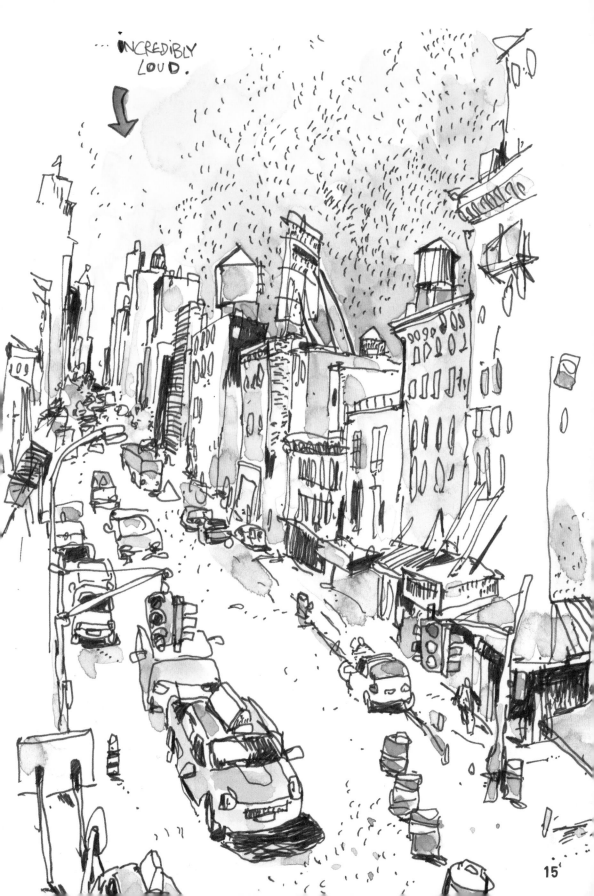

Notes are permitted

Written notes are not only permitted in sketchbooks, they are encouraged, as they increase narrative force. By adding information, comments generate a new level of meaning. For example, if you write next to your drawing, "The stench was unbearable," or "I love her beautiful singing voice," these notes contain information that you can hardly transmit with "only" your drawing.

And don't forget that although writing is a distant relative of drawing, it is still part of the family. Every kind of writing evolved from drawing; over millennia, pictorial language evolved to written language, so it's hardly surprising that writing and drawing go so well together. Your drawing and your handwriting spring from the same source and will meld organically. So don't be afraid to add handwritten notes to your drawings.

Notes don't simply document the time and place—additional information sometimes puts your drawing in a whole new light. There is a big difference between a woman sitting on the street in the middle of the night because she feels like it and because she is forced to sell packets of tissues to survive.

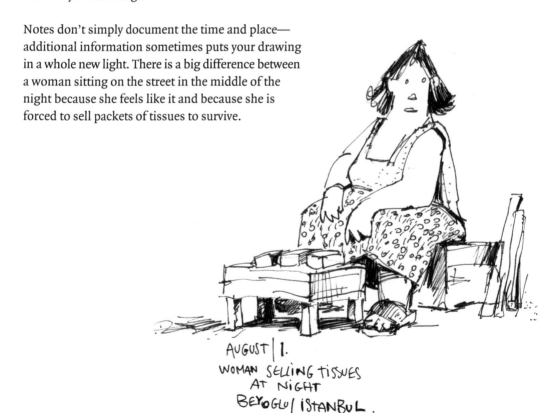

AUGUST|1.
WOMAN SELLING TISSUES
AT NIGHT
BEYOGLU|ISTANBUL.

Journaling

When you pick up a working sketchbook, you'll notice right away the thing that may not have been so obvious when you bought it: your sketchbook is not just a book of drawings, but is also a journal. Its pages tell of many days, weeks, and months of your life. In addition to your drawings, you will discover your day-to-day life in your books, visits to foreign cities, maybe images of your girl-friend, perhaps some figures you drew during a toothache or a landscape from a picnic. In other words, a sketch-book chronicles your life. If you have added comments, ideas, place descriptions, and similar things to your draw-ings, looking back on them will greatly enhance your memories. Your sketchbook—or sketchbooks—will one day tell you a lot about yourself and your life.

The purpose of a journal is always to develop yourself and your own opinions. Remember: designing is mainly a decision-making process. And in order to make a deci-sion, you have to know where you stand. In the long run, a sketchbook will help you on this journey.

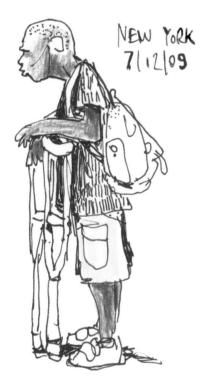

NEW YORK
7|12|09

CORNER
10th AVE AND
W. 23RD St.

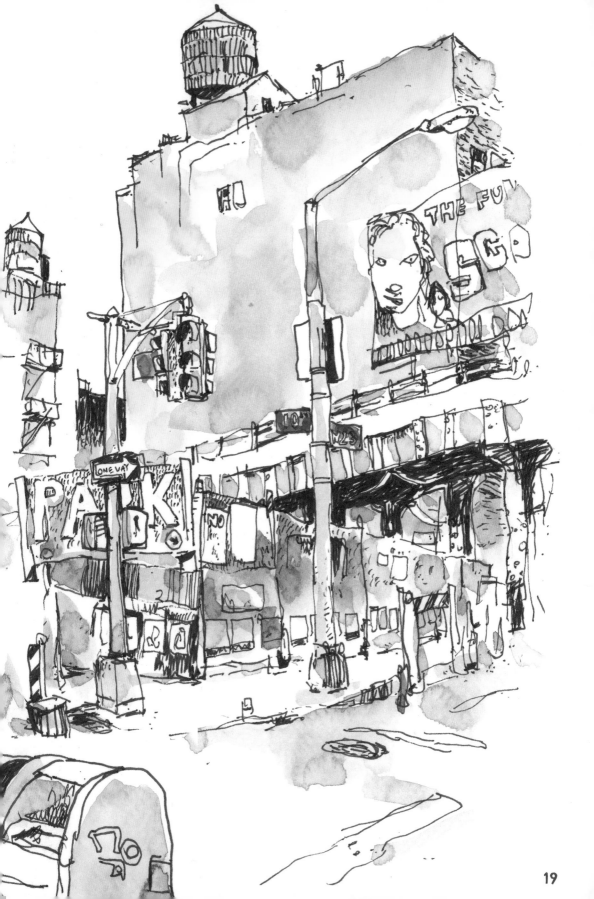

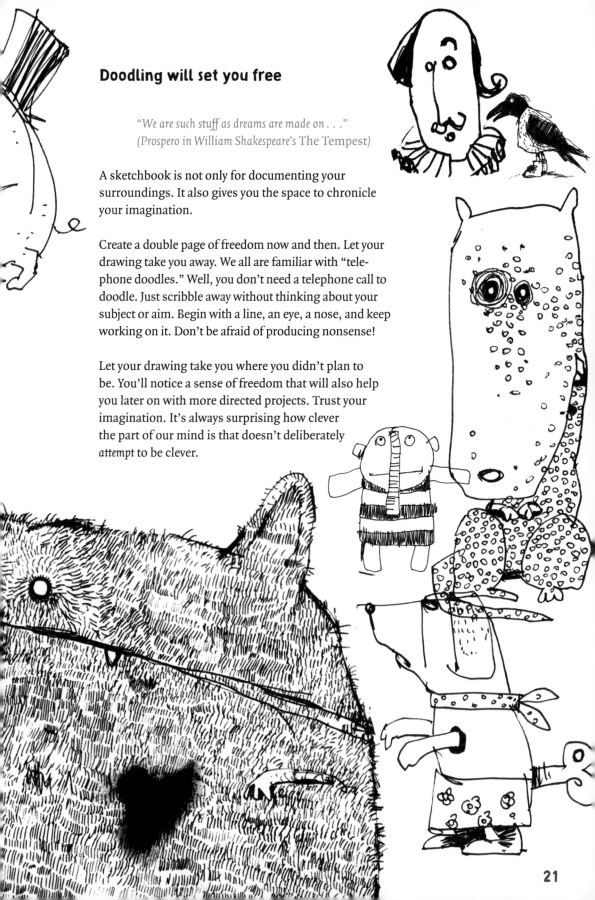

Doodling will set you free

"We are such stuff as dreams are made on . . ."
(Prospero in William Shakespeare's The Tempest)

A sketchbook is not only for documenting your surroundings. It also gives you the space to chronicle your imagination.

Create a double page of freedom now and then. Let your drawing take you away. We all are familiar with "telephone doodles." Well, you don't need a telephone call to doodle. Just scribble away without thinking about your subject or aim. Begin with a line, an eye, a nose, and keep working on it. Don't be afraid of producing nonsense!

Let your drawing take you where you didn't plan to be. You'll notice a sense of freedom that will also help you later on with more directed projects. Trust your imagination. It's always surprising how clever the part of our mind is that doesn't deliberately attempt to be clever.

The right and wrong ways to draw

My granny liked to comment on my early drawings by saying that you had to be able to precisely depict everything around you before you were allowed to paint however you like. "Picasso learned to draw properly before he became abstract," she would say.

This kind of advice was typical for my granny, who also held the opinion that you had to eat your potatoes and salad before you got dessert. Art that was fun was obviously suspicious. Fun had to be earned first through hard work.

The techniques of drawing and sketching are sadly not at all suitable for anyone who wants to please everyone (including my granny). If you want to reproduce something "just as it is," you can turn to photography.

Of course, drawing can reproduce, but the strength of sketching lies in one's own position, one's own way of seeing. Drawings that attempt to imitate photos seem—unsurprisingly— stiff and boring.

Adding or removing a component, drawing over or caricaturing an element, *making mistakes*—this is what brings a drawing to life.

So my granny's advice had me barking up the wrong tree. I learned to draw "better," but it was only thanks to my enthusiasm that this advice did not drive the joy of drawing out of me completely. Drawing is a learnable skill that requires both effort and discipline. The strength of sketches, however, is their immediacy, their expression, their emotion and creativity: the fun of simply drawing. You'll get "better" at it all by yourself.

If it's fun, you'll do it more often. And if you do it more often, you'll do it well.

IN BUS #19
JANUARY 13, 2009

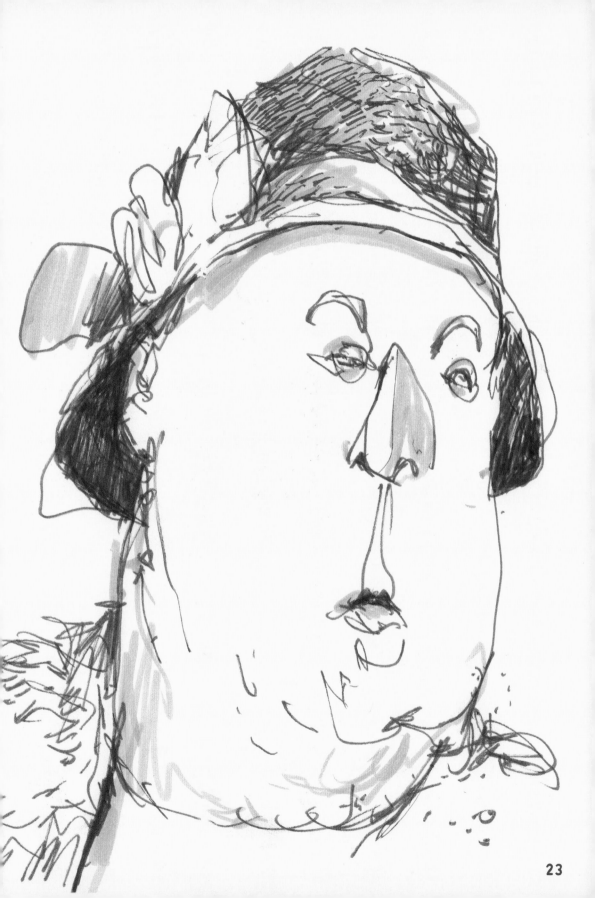

Specialty pens

Off-the-shelf pens, like rollerball pens, felt-tip pens, and fountain pens are particularly suitable for working in sketchbooks. For one, they're inexpensive and you can work with them rapidly and fluidly. Additionally, they don't smear quickly or bleed through the page.

If you use waterproof pens, you can later enhance your drawing with watercolors or, as in this example, give them depth by using a gray felt-tip pen. If you use water-soluble pens or fountain pens, you can paint over your lines with clear water, thus creating appealing grays or color gradations.

Tip:
Use colored pens. Art and office supply stores have all sorts of them—often intended for use in the office or for children—that are excellent for drawing. Try some out and see what works best for you.

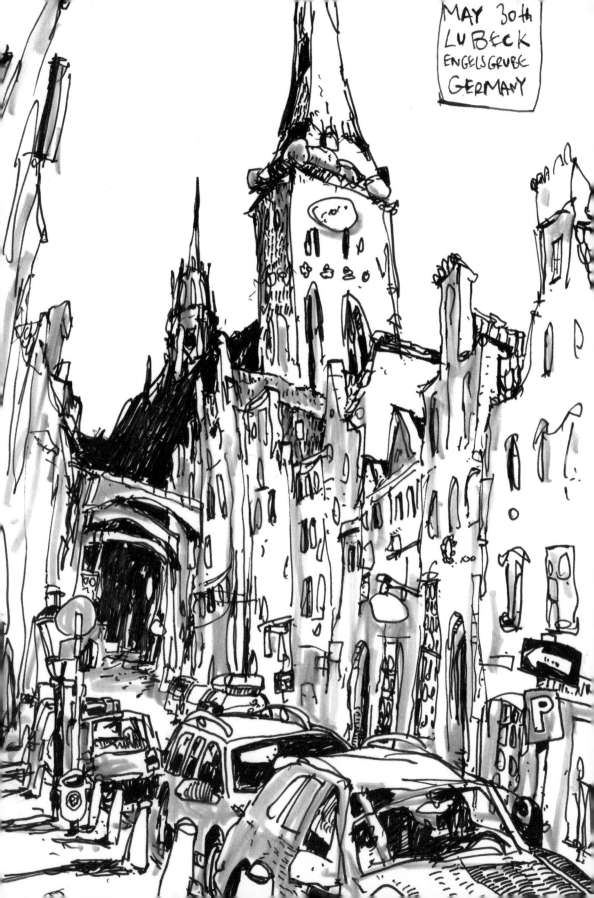

MAY 30th
LUBECK
ENGELSGRUBE
GERMANY

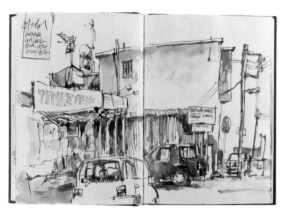
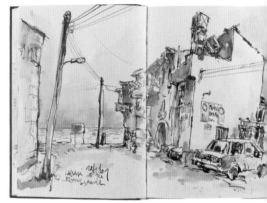

Tip:
Steel quills are not very good to use with ink in sketchbooks since they quickly scratch through the paper. An alternative is the reed pen.

You can carve reed pens from thin bamboo or reeds. First, cut the bamboo at a 30-degree angle with a sharp knife. The circular shape of the bamboo will make the cut somewhat round rather than straight.

Next, cut a slit in the long end and then sharpen the reed pen carefully. Make sure a little wood is left over on both sides of the slit.

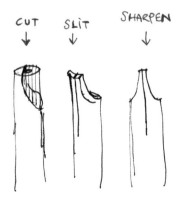

Sepia ink

Working with sepia ink was common in ancient times; it is one of the oldest materials in drawing. Medieval book illustrators used it just as modern artists do today. The brown hue, originally made from octopus ink, is excellent for drawing and coloring. Sepia ink can be used as a drawing ink as well as a glaze when diluted. When coloring with sepia ink, it's wise to use lots of water. Also, as when working with watercolors, the white of the paper is the lightest color (see page 39).

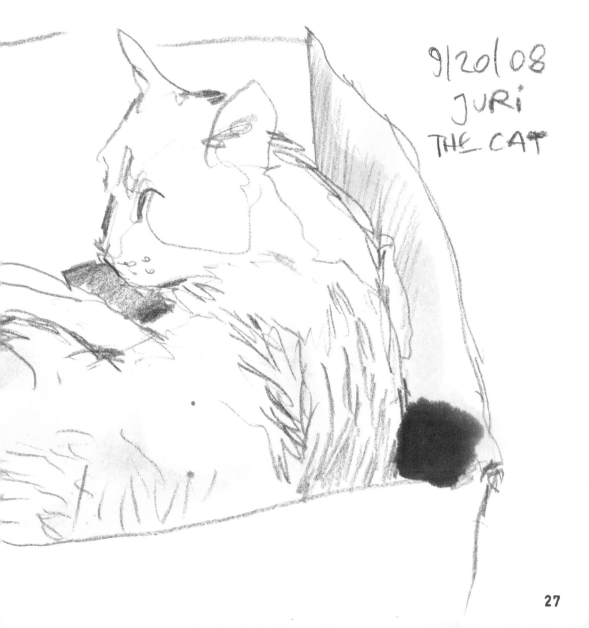

9/20/08
JURI
THE CAT

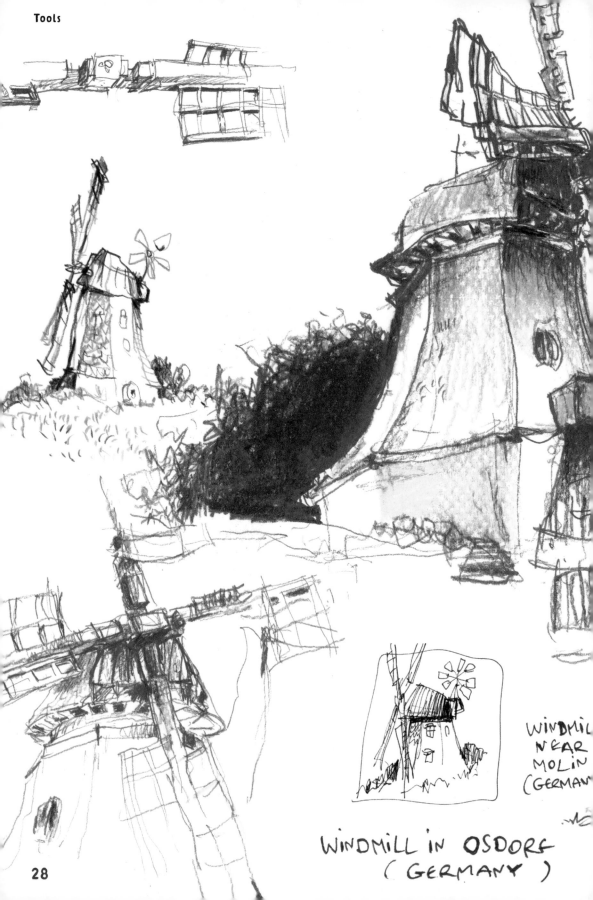

WINDMILL
NEAR
MOLIN
(GERMANY

WINDMILL IN OSDORF
(GERMANY)

28

Colored pencils

Colored pencils are available in every hue imaginable. They are suitable for both drawing and coloring.

You can work with colored pencils just as with graphite pencils, the only difference being that most colored pencils cannot be erased. The drawing technique is exactly the same: by consolidating the strokes you create deeper hues, and the lightest color is the white of the paper.

In addition, when working with colored pencils, you can layer different hues to create mixed colors. In sketchbooks, colored pencils are especially suited for adding colored accents to drawings and for making rapid notes of important colors.

It's also nice to use colored pencils directly for drawing. For instance, it is very effective to make a line drawing with two or three colored pencils and use the transition of colors to intensify the contrast between different parts of the picture.

Tip:
Don't throw away the "stumps" of pencils you've sharpened down; save them for traveling.

It's a lot easier to transport an assortment of stumps than a box of colored pencils, and a stump is usually exactly the amount of color you'll need.

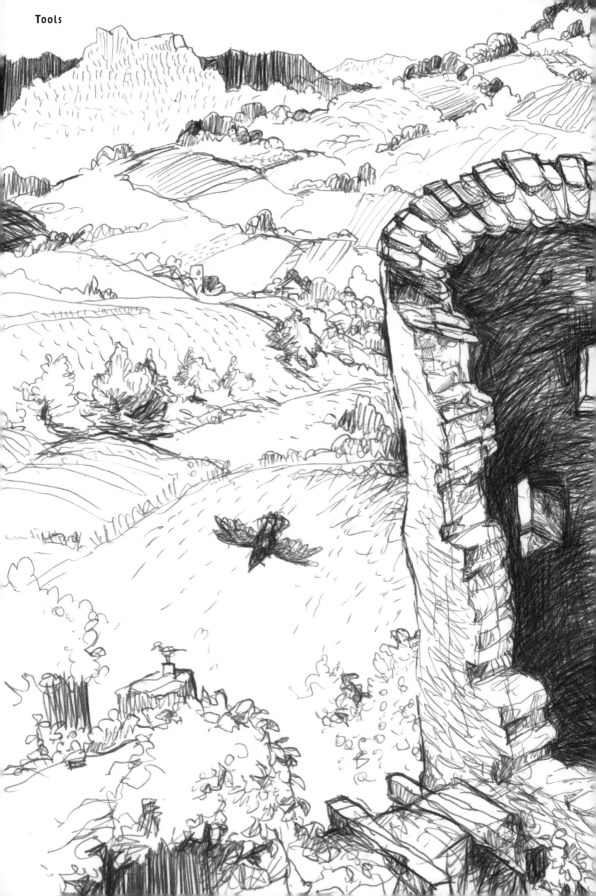

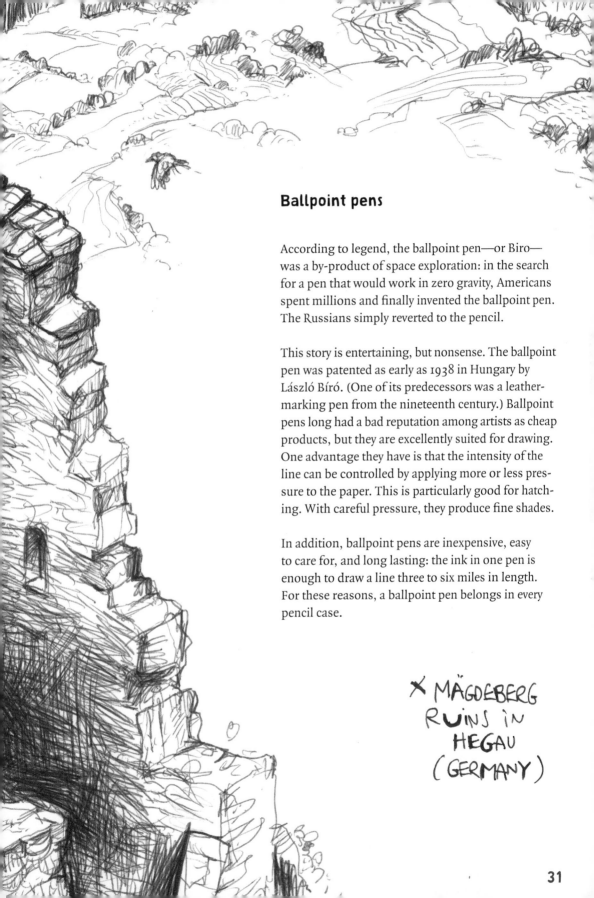

Ballpoint pens

According to legend, the ballpoint pen—or Biro—was a by-product of space exploration: in the search for a pen that would work in zero gravity, Americans spent millions and finally invented the ballpoint pen. The Russians simply reverted to the pencil.

This story is entertaining, but nonsense. The ballpoint pen was patented as early as 1938 in Hungary by László Bíró. (One of its predecessors was a leather-marking pen from the nineteenth century.) Ballpoint pens long had a bad reputation among artists as cheap products, but they are excellently suited for drawing. One advantage they have is that the intensity of the line can be controlled by applying more or less pressure to the paper. This is particularly good for hatching. With careful pressure, they produce fine shades.

In addition, ballpoint pens are inexpensive, easy to care for, and long lasting: the ink in one pen is enough to draw a line three to six miles in length. For these reasons, a ballpoint pen belongs in every pencil case.

X MÄGDEBERG RUINS IN HEGAU (GERMANY)

And, of course, pencils

It's said that the Egyptians poured lead into papyrus reeds five thousand years ago to make writing implements. When graphite was discovered, it was mistaken for lead, which may be why many still call the pigment core the "lead." The "lead" of a pencil is actually made of graphite and clay. The mixture of these two components determines the hardness of the pencil; the more clay it contains, the harder the pencil. Softer pencils are better for drawing.

In terms of labeling, H means hard in pencils, and B soft. A pencil labeled HB is in the middle. The softer the pencil, the higher the number before the letter B; 2B and 3B pencils are best for drawing.

The major advantage of pencils is that you can use varying degrees of pressure or cover to create gray shades. Using a pencil, you can approach your subject very carefully, but you can also produce strong, forceful lines. Best of all, you can erase pencil lines! Merely the possibility of correction gives beginners, in particular, that crucial feeling of security. Hence, a pencil unites an entire range of possibilities in one simple, inexpensive utensil.

FACTORY .BROOKLYN
NEW YORK CITY
JULY 14
2009

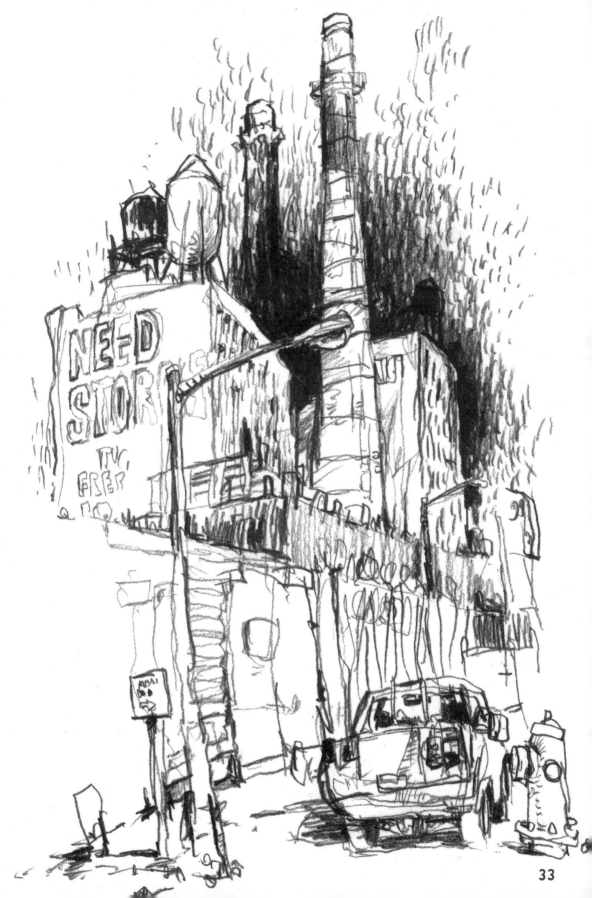

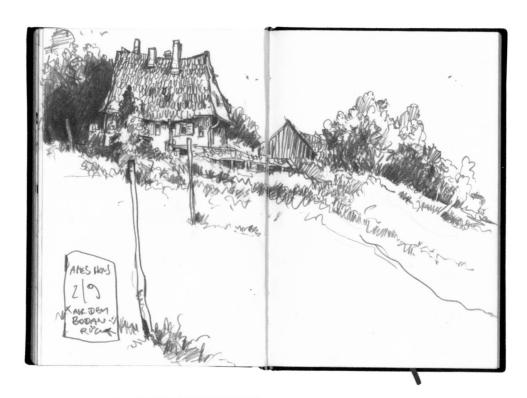

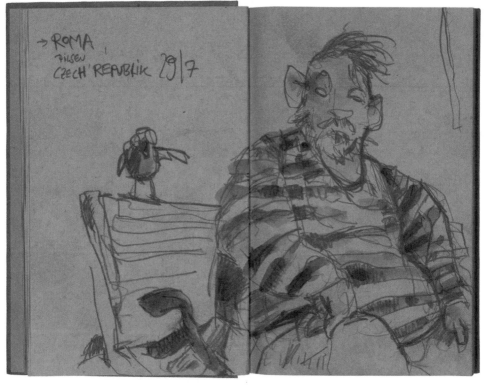

Although the pencil is an all-around talent, however, I wouldn't recommend it for sketchbooks without reservations.

The disadvantage of pencils is that they constantly need to be sharpened. Even retractable pencils, with replaceable and extendable leads, are no exception. This can be disruptive while sketching, especially when rapidity is demanded, as your implement will get dull at all the wrong moments. In addition, pencils (even colored pencils) are quite fragile. If you drop a pencil, the lead inside often breaks, which you won't notice until the next time you try to sharpen it. The lead crumbles and can no longer be sharpened properly.

I also find it bothersome that soft pencils, in particular, tend to smear. For a regular drawing, you can prevent smudges by laying a piece of white paper under the ball of your hand. But in a sketchbook, drawings tend to rub off onto the opposite page or smudge from friction between the pages.

The solution is to use a fixative. However, this means having a spray bottle on hand at all times. I usually get around this by laying a sheet of white paper between the pages of my book and fixing the pencil sketch at a later time. Contrary to what many people think, hairspray is not a suitable substitute for a fixative, since it yellows and is sticky.

Tip:
Pencil lines can also be fixed by painting over them, especially with watercolors. Apply a thin coating of color and they won't smudge anymore!

Markers, glitter pens, and beyond

The sheer number of tools you can use for drawing is amazing. You can draw with indelible pencils, with the timber marking pens used by forestry workers, with brush pens and highlighters.

Above all, there are many kinds of felt-tip pens, a family that includes markers made especially for drawing. Markers are available in every hue and are (for good reason) very popular with artists. Unfortunately, markers are quite expensive and they also usually soak through the pages of sketchbooks, so require special coated paper. (Recently, art supply stores have begun carrying so-called marker sketchbooks for this purpose.) In addition, many stationery stores offer hundreds of pens and pencils made not for art drawing, but for writing and decorative purposes. There are glitter and neon pens, marker pens, highlighters, and gold and silver pens that can all be used for drawing, particularly for special effects.

The only downside of using these kinds of pens is that you will not be able to reproduce your drawings true to the original. When you scan your sketches and print them, you'll notice that the lovely glitter effect gets lost since the pigments in these pens are often artificial. They contain luminous paints or metal pigments that cannot be reproduced by color printers.

I nevertheless advise you to try out various pens. Draw with everything you can get your hands on. When all else fails, you can even draw with espresso.

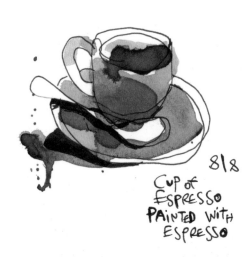

8\8
Cup of
Espresso
painted with
Espresso

Tip:
A few classic media are not well suited for use in sketchbooks. These include media that smudge when you turn the pages, such as wax crayons, pastel crayons, and charcoal. In addition, any medium that requires a long drying time, such as oil paint, is impractical.

Tools

Tip:
A small, off-the-shelf watercolor set is sufficient for a sketchbook. A small metal cup is also useful.

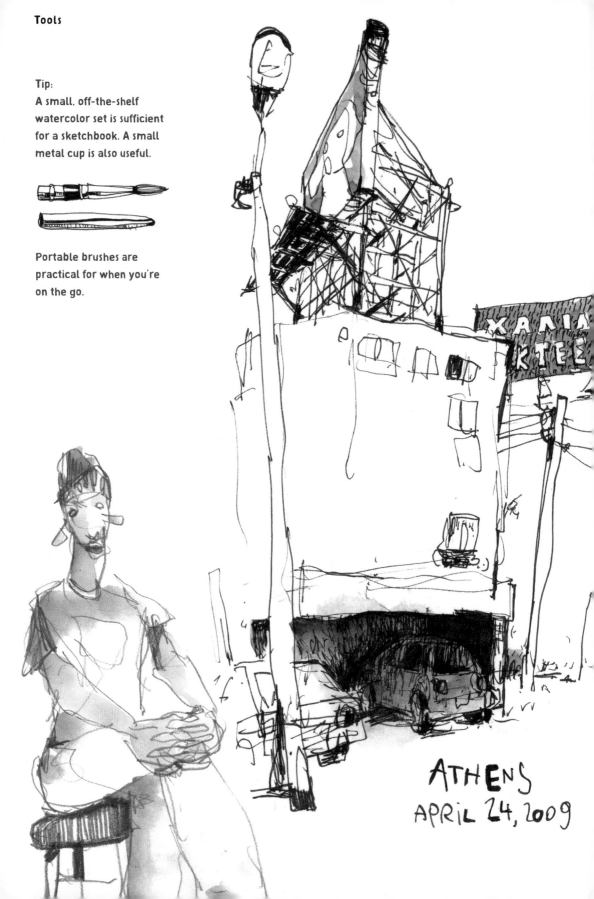

Portable brushes are practical for when you're on the go.

ATHENS
APRIL 24, 2009

Watercolors

The classic way to color in sketchbooks is to use watercolors. Watercolors possess natural hues, are quick to apply, and are very easy to carry in handy boxes. Applied incorrectly, however, watercolors can look pretty awful. Also, it's quite easy to use watercolors incorrectly. As practical as they are, it takes a good deal of time to master them.

This is well worth the effort, though, since watercolor glazes (layers of color) can greatly enhance drawings. The important thing to remember when employing glazing techniques is omission. There is no white watercolor paint; the white (and all light hues) is the unpainted surface of the paper. Therefore, with watercolor we always work from light to dark. Basically, watercoloring is like drawing: fill the dark areas with color and leave the light areas empty.

In sketchbooks, it is often sufficient to color only a few accents. Paint what seems important to you and bravely leave the rest unpainted. Your eyes will fill in the rest.

→ AS THE **NAME** IMPLIES:
USE A **LOT** OF WATER !

HURRY!

If you want to work on larger surfaces with watercolors, you have to work fast. Begin with the lighter areas (such as the sky) and work your way to the darker sections.

The important thing is not to use water too sparingly. For example, to paint the sky, mix plenty of paint and water beforehand so you don't run out halfway through. If you have to interrupt your work to mix more paint, it will be visible later on in your painting.

The rule with watercolors is to work quickly. The faster you work, the more convincing the results will be.

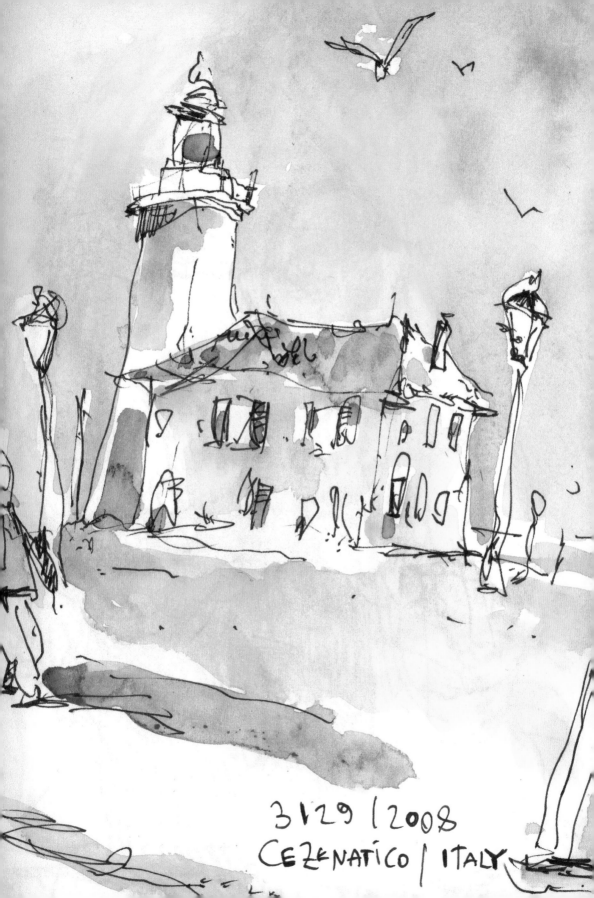

3129 12008
CEZENATICO / ITALY

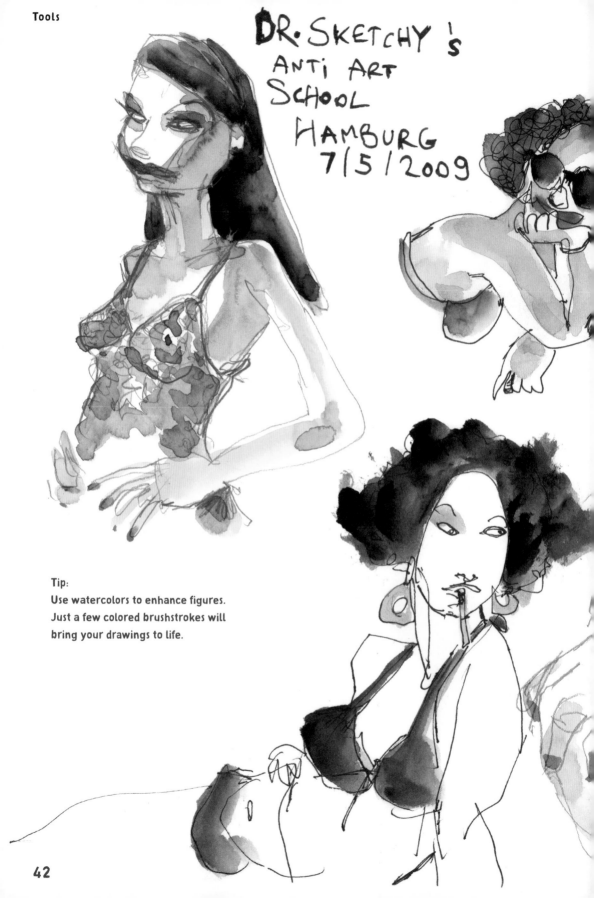

DR. SKETCHY'S
ANTI ART
SCHOOL
HAMBURG
7/5/2009

Tip:
Use watercolors to enhance figures.
Just a few colored brushstrokes will
bring your drawings to life.

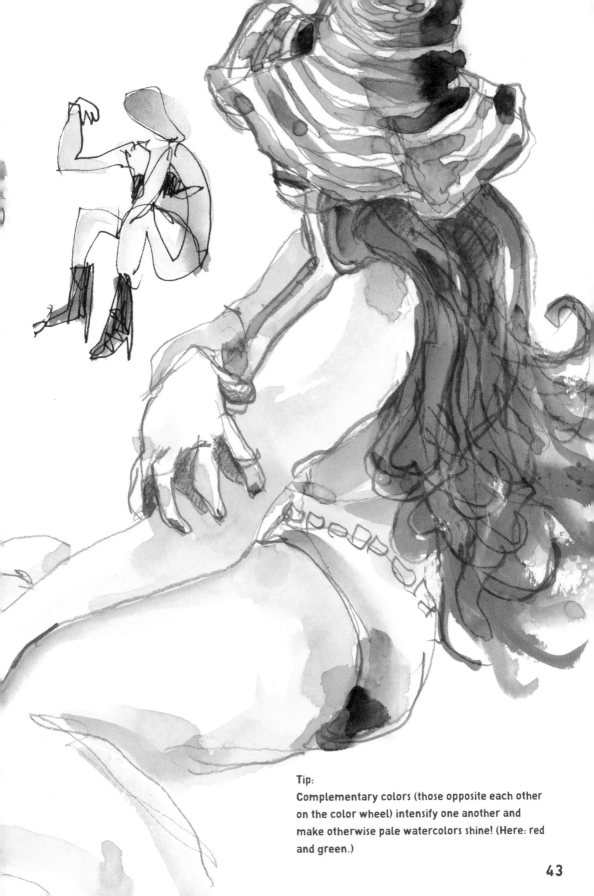

Tip:
Complementary colors (those opposite each other
on the color wheel) intensify one another and
make otherwise pale watercolors shine! (Here: red
and green.)

43

Collage

Collage offers endless possibilities: you can integrate admission tickets, restaurant bills, labels, bus tickets, slips of paper with telephone numbers, business cards, personal notes, and thousands of other things in your sketches. All you need is a little glue and imagination! Collages are inspiring and have narrative force. Years later, they will call up memories as no photograph can.

The most appealing thing about using mixed materials is when you integrate them into your drawing to provide additional information. Add the label from a nasal spray bottle to a portrait of someone who has a cold or, as in this example, a chicken soup label for a sketch of having the flu while traveling. In other words, use collage to add meaning to your drawings!

Tip:
Stamps can also enhance your drawings. When you are drawing in museums, restaurants, shops, cafés, or tourist sights, ask them to "stamp" your page. The stamp documents the event and is an additional design element.

FEEL A LiTTLE Sick ON DECEMBER 29, 2008

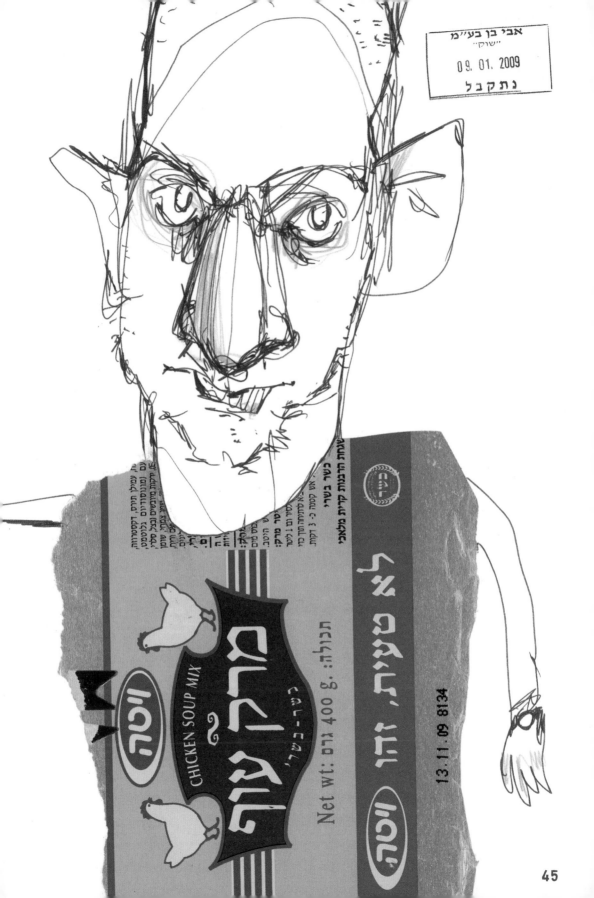

45

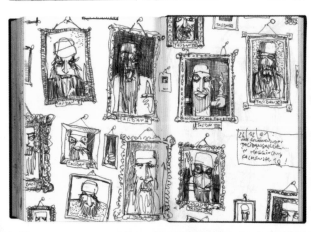

Visualizing your ideas

When I was a child, I often dreamed that I was holding something really great in my hands—for instance, lots of chocolate. During the dream I became aware that when I woke up, I'd leave the chocolate behind. That really made me think: isn't there a way to transport something from my imagination to reality? Of course there is!

With a drawing, you can depict not only things that are real, but also those that only exist in your mind. Use drawings to visualize your ideas! Use your sketchbook for your scribbles and drafts and to explain your ideas to clients with a few quick lines (as with my sketches for editorial illustrations, shown opposite). One thing is certain: ideas are hard to photograph, but very easy to draw!

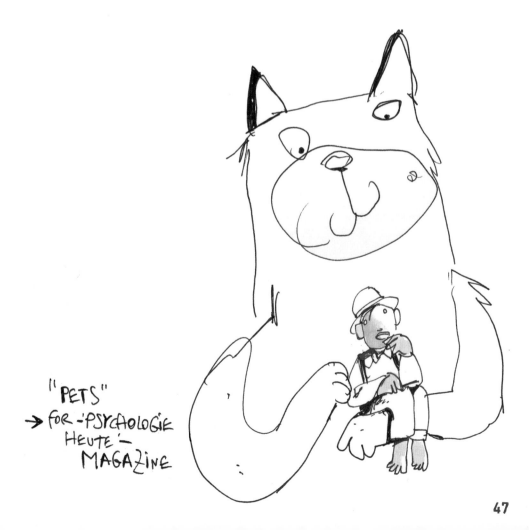

"PETS"
→ FOR -'PSYCHOLOGIE
HEUTE'-
MAGAZINE

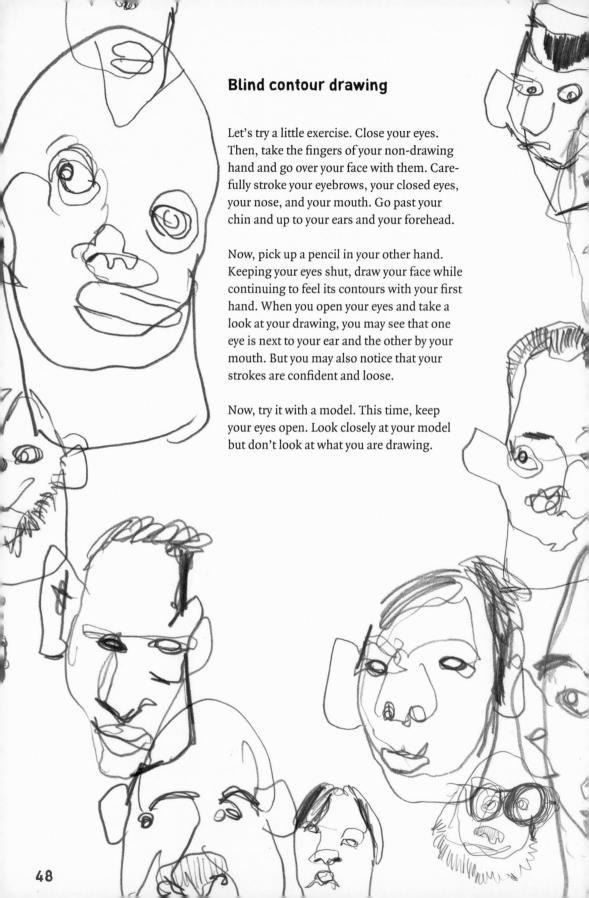

Blind contour drawing

Let's try a little exercise. Close your eyes. Then, take the fingers of your non-drawing hand and go over your face with them. Carefully stroke your eyebrows, your closed eyes, your nose, and your mouth. Go past your chin and up to your ears and your forehead.

Now, pick up a pencil in your other hand. Keeping your eyes shut, draw your face while continuing to feel its contours with your first hand. When you open your eyes and take a look at your drawing, you may see that one eye is next to your ear and the other by your mouth. But you may also notice that your strokes are confident and loose.

Now, try it with a model. This time, keep your eyes open. Look closely at your model but don't look at what you are drawing.

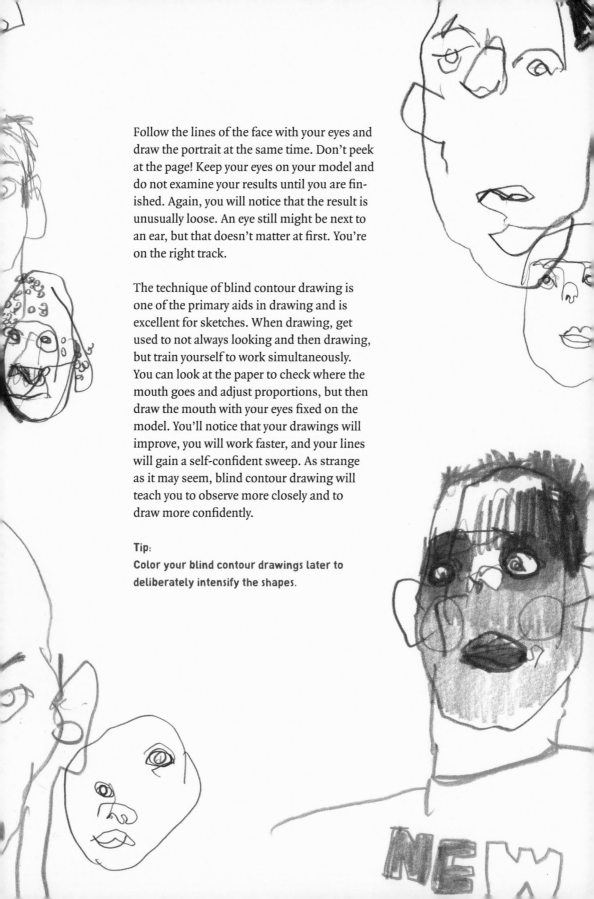

Follow the lines of the face with your eyes and draw the portrait at the same time. Don't peek at the page! Keep your eyes on your model and do not examine your results until you are finished. Again, you will notice that the result is unusually loose. An eye still might be next to an ear, but that doesn't matter at first. You're on the right track.

The technique of blind contour drawing is one of the primary aids in drawing and is excellent for sketches. When drawing, get used to not always looking and then drawing, but train yourself to work simultaneously. You can look at the paper to check where the mouth goes and adjust proportions, but then draw the mouth with your eyes fixed on the model. You'll notice that your drawings will improve, you will work faster, and your lines will gain a self-confident sweep. As strange as it may seem, blind contour drawing will teach you to observe more closely and to draw more confidently.

Tip:
Color your blind contour drawings later to deliberately intensify the shapes.

Your line is you

Draw in whatever way comes naturally. Every artist has something like a "natural line" that he or she was practically born with. Once you learn to accept yours, you'll have taken a big step forward. Don't look at others' lines and do not attempt to imitate other artist's "better" or "more modern" styles of drawing. Anyone can learn tricks and gimmicks but you must learn to accept your own line and the way you draw—it's your own unmistakable signature! In time, you'll come to realize that your signature is beautiful.

So draw "by guess and by gosh." Believe me: what makes drawings exciting is what is authentic and personal. Your own drawings will profit from it.

7/15/2008

BLUE

PURPLE

Mistakes are allowed!

This is what we do about mistakes on the computer: Command Z. Of course, this isn't possible in a sketchbook, and that's the way it should be.

The problem with undoing is that it's too easy. You rob yourself of the potential that your mistakes hold.

You can learn from your mistakes, but only if you are legitimately annoyed by them and don't just flick them away by snapping your fingers. Only if your mistakes bother you can you learn to avoid them the next time around.

The second thing that makes mistakes useful is this: if you always do everything "right," you'll be limited to reproducing what you already had in mind. But what's usually in your mind are pictures you've already seen: other people's pictures.

As an artist, you should not look for second-hand pictures, but make your own! Coincidences and mistakes will stand by you, cheering you on. Sometimes we need an unlucky splotch of coffee on the page or a ruined drawing for new ideas to dawn on us.

Tip:
Do not tear any "failed" pages from your sketchbook. It turns out ugly and also ruins the opposite page in the binding. Instead, revise the page on another occasion. Continue drawing on it, make a collage, or use some color. You'll be surprised by what a flawed page can offer.

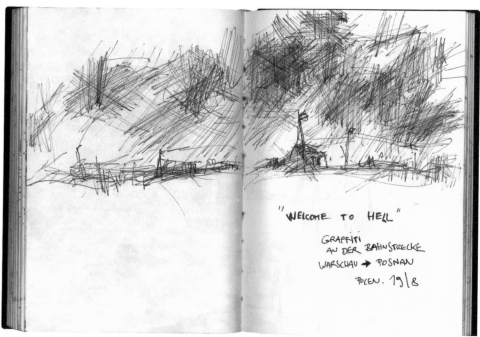

Drawing what you feel

How you see things and the feelings you have for your subjects impacts your drawings. Drawing is not only for depicting and reproducing subjects, but also for intensifying what you've seen and adding emotion to the subject. This will only make the drawing better!

So don't be afraid to draw the way you feel. Use your choice of medium to assess things, and to portray things compactly or expansively, erratically or peacefully. Add elements, such as color, to reveal how you feel about the subject. The red in the background of the rider above left is not just there to fill the background, but to transport an emotion.

In art, the emotional middle ground is deadly. The more opinionated a drawing is, the more entertaining it will become!

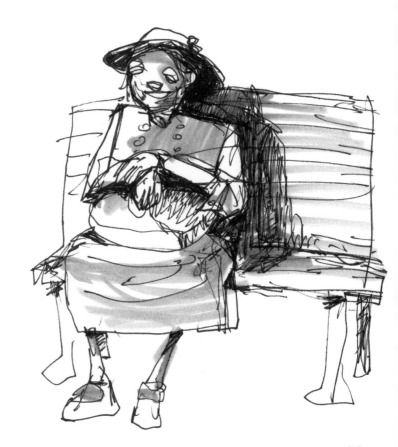

Drawing is not photography

Unlike in a photograph, you do not need to show *everything* in a drawing.

When you snap a photograph, everything is captured as pixels or on film: the foreground, the background, the subject, and the surroundings. The picture is filled from one edge to the other, top to bottom. With a drawing it's simpler. You can decide then and there what's important and what's not.

This is part of the narrative power of drawings: lines are denser in places that are important to the artist, and what is not important can simply be left out. Drawing creates more than depth of focus—it allows insignificant things to disappear and conjures significant things out of nowhere.

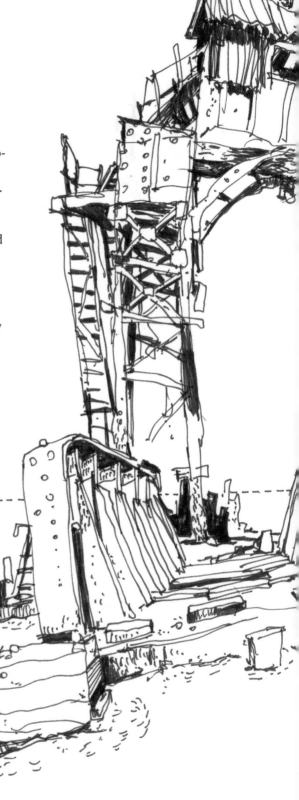

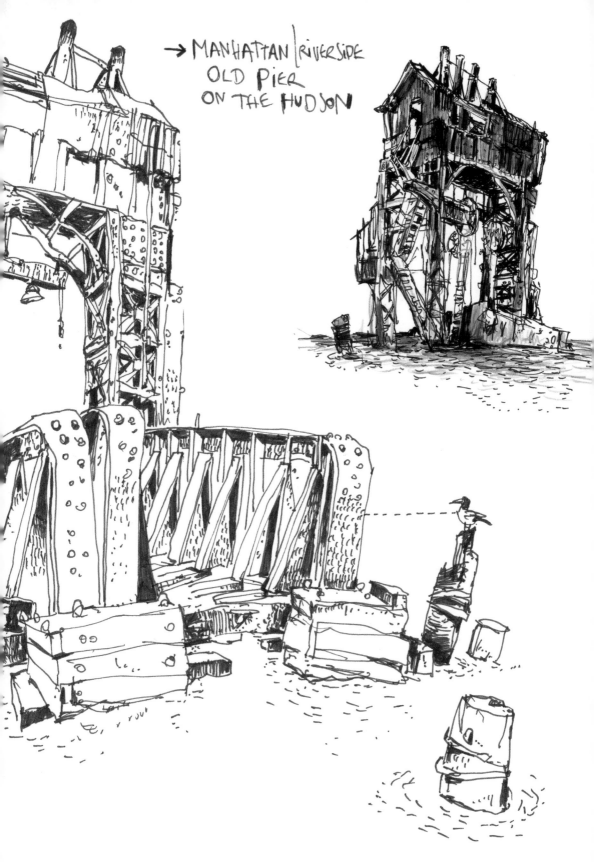

→ MANHATTAN/RIVERSIDE
OLD PIER
ON THE HUDSON

→ PHONE BOOTH
PILSEN, CZECH REPUBLIC

Letting imagination complete the picture

When we talk about drawing, we have to spend a few moments discussing the white of the paper. "Empty" space is crucial, because the viewer's imagination fills up the area surrounding your drawing.

We all know what a sidewalk, the surface of a wall, or a cloud looks like and that is why we do not normally notice these things as readily as we notice special aspects of a place. This is why pictures work in isolation, without making us ask about the surroundings. The white area in a drawing is the world that viewers complete in their minds. You can throw single aspects of a stroll outdoors on the paper and still be certain that they will be understood. The drawings are the moments that stay in our memory; the white areas are the everyday things we don't notice.

Therefore, as an artist you should create focal points and show only some aspects of a place—the viewer's imagination will fill in everything that's missing in the surrounding world.

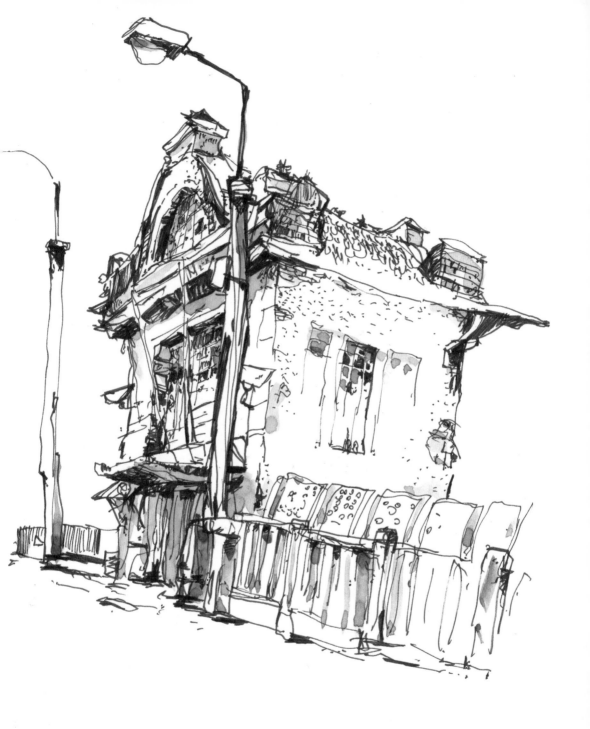

7/26
(TRAIN STATION!)
PILSEN
CZECH REPUBLIC

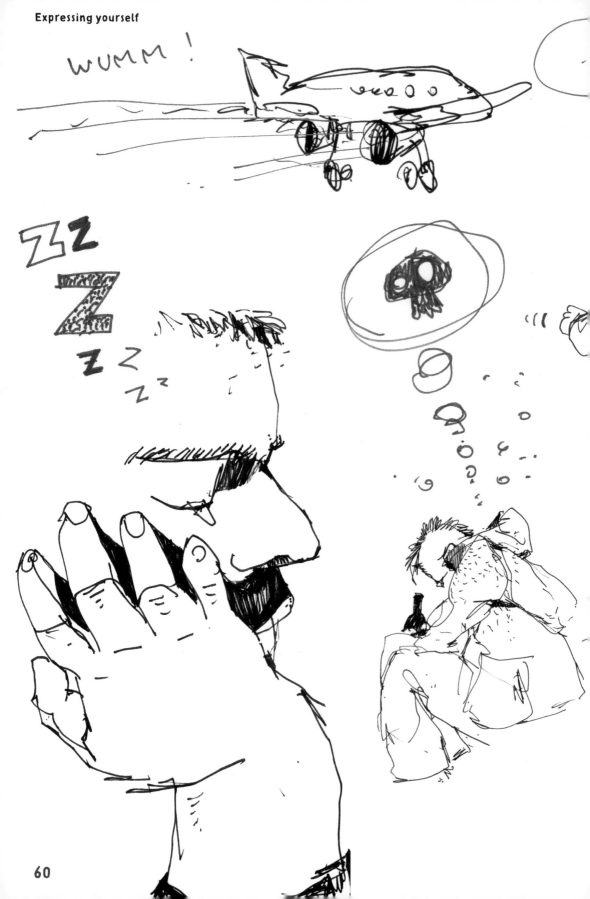

WUMM !

Drawing the invisible

As every child knows, you can draw the sun's rays. Of course, if we look closely, we see that no lines are emitting from that star. The sun is merely a bright ball in the sky. We nevertheless accept the rays in a drawing without objection as well as the wavy lines rising from a drawn sausage. We know right away that they mean odor or heat.

Of course, you can write next to a figure, "He is moving," but you can also draw two lines. The viewer will know that they stand for motion. Our culture has agreed upon a visual vocabulary. Arrows, speech bubbles, punctuation marks, and similar are also part of this visual language. So feel free to use the respective abbreviations; use the cartoon vocabulary.

Tip:
Attempt to find your own solutions. Invent new expressions! Perhaps noise can be drawn as a pattern or sadness as hatching?

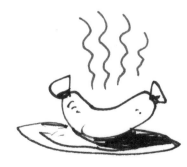

61

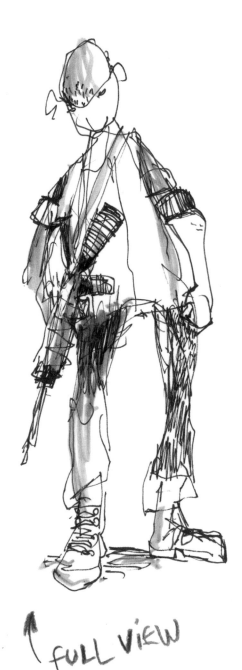

FULL VIEW

Shot settings and westerns

If you can learn one thing from western movies, it's how to draw.

Westerns can be used to explain how one of the most elementary techniques in drawing works: shot settings. It's all quite simple. Complicated-sounding terms like long shot, knee shot, and extreme close-up mean nothing more than the distance between the viewer and the subject, and therefore how big the subject is in a drawing.

Using these terms in illustrations changes everything, though. Depicting a subject very close up brings it closer to us. It suddenly becomes more emotional and direct, confronting us in a different way than subjects we only draw randomly in the background.

If you deliberately use different shot settings in a series of pictures, such as in a book, it makes the series more interesting. The switch between settings creates accents. Therefore, it is important for artists to know and use the various shot settings purposefully.

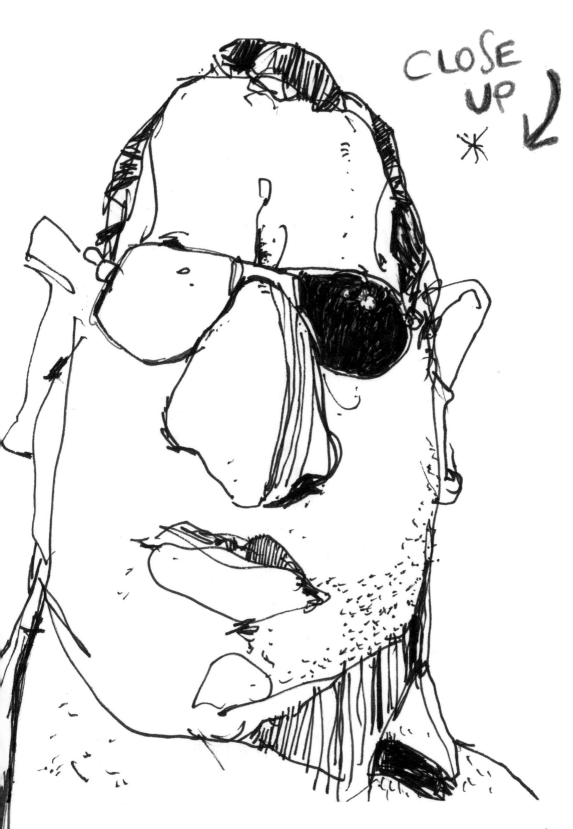

CLOSE UP

63

Five types of shot settings

Here are the five most commonly used shot settings, from very far away to very close up:

1. The widest setting is the *extreme long shot*, for example a landscape. Subjects appear as tiny figures, like the cowboy on the horizon.

2. The next setting is the *long shot*. The subject is much closer, about ten yards away.

3. A *knee shot* shows the figure so close that it is cut off mid-thigh (below the "holster").

4. The *medium shot* is often used in interiors and shows part of the figure, for example seated at a table. The detail goes from about head to waist.

5. The closest setting, of course, is the *close-up*. It shows the head, the face, or sometimes only details like the eyes.

Attempt to use shot settings consciously in your drawings. For instance, draw the same subject in various shot settings or deliberately switch settings to tell a story.

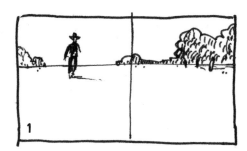

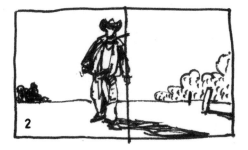

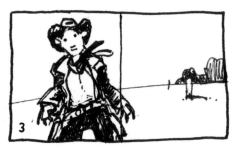

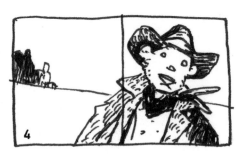

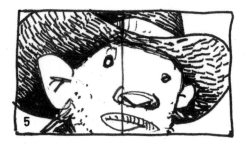

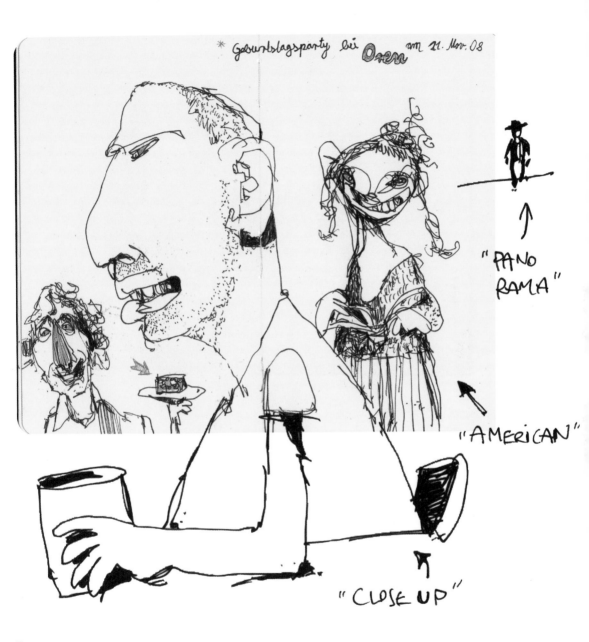

Tip:
It can be particularly interesting to combine shot settings within one picture. To keep with our western example, this could be a close-up of a cowboy whose dueling enemy can be seen very small in the background. Try to unite different settings. Zoom in on small details to depict tiny things big. In the background, contrast this with other settings.

**Extreme
long shot**

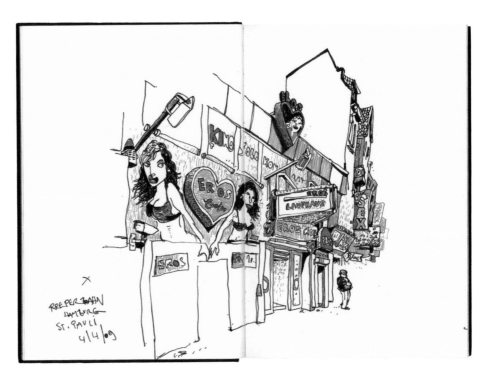

Medium shot

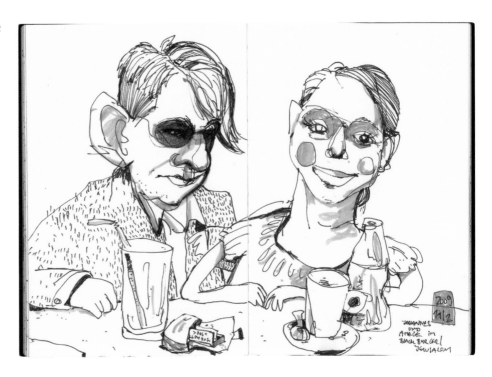

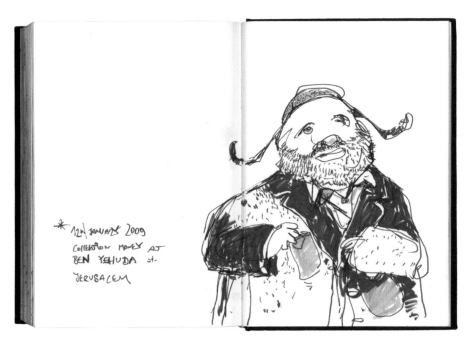

※ 12th JANUARY 2009
COLLECTION MONEY AT
BEN YEHUDA st.
JERUSALEM

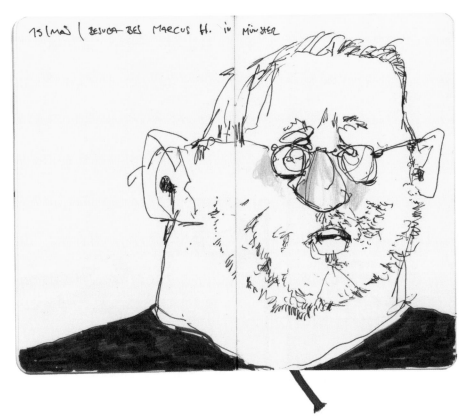

15 [MAI] BESUCH BEI MARCUS H. in MÜNSTER

Getting a feel for composition

It is impossible to do justice to something as important as composition in one or two pages. The reason I am attempting to do so nonetheless is that I do not believe there is a recipe for learning it.

Of course there are rules, but you first need to develop a feel for good composition. Your sketchbook can help you do just that.

As an artist, you will encounter the format of your open book—a rectangular landscape format divided down the center—quite often. You will discover it in magazines and brochures, in booklets and, of course, in other books. In addition, landscape formats dominate in film, computer games, and websites.

At the same time, you can use every single page of your book for portrait formats. This makes the sketchbook an ideal place to practice almost any type of design, and the more you work with a sketchbook, the better you will develop a feel for image composition.

So when drawing, pay attention to how your subject is positioned on the page. Use the entire area of your two pages and place your subject in an interesting way. For instance, if you draw two vases, it is less interesting to locate each at the center of the page than to stagger and crop them.

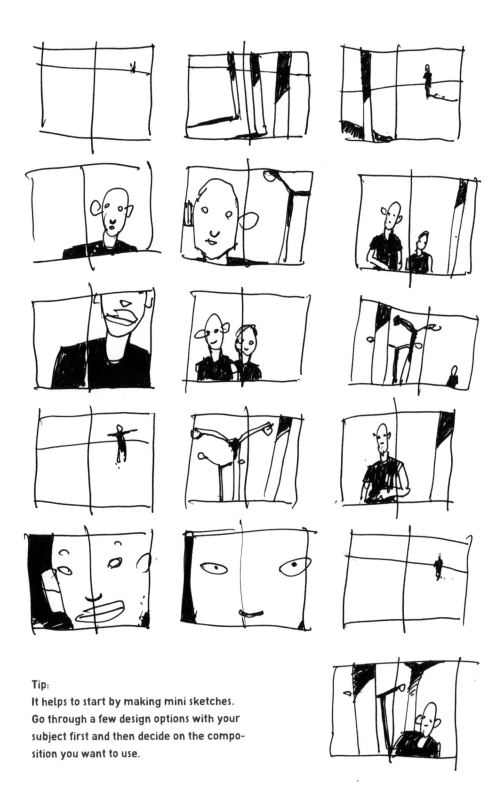

Tip:
It helps to start by making mini sketches.
Go through a few design options with your
subject first and then decide on the compo-
sition you want to use.

69

Weight and balance

Although lines on paper weigh nothing, visually they can add a lot to the scales. Every composition possesses an inner weight; drawings have visual focal points. For example, if you push your subjects into one corner, the balance of the drawing "tips" in that direction. If you draw an object in the opposite corner, your drawing goes in another direction.

Depending on your purpose, this can be very exciting and will enrich your drawing skills. So use this technique deliberately to develop a feel for weight. Don't stubbornly copy what you see, but arrange your subject whichever way you want. The visual weighting can be easily integrated into the composition. This is particularly true of incidental details such as a shadow, lamppost, or bird, which can often be "shifted" a bit. Take liberties with reality: your drawings will be more interesting when you set compositional priorities.

In the above right example, the shadow supports the bottle, thus preventing it from tipping too far to the right.

In the middle example, the lamppost does the same. It provides a visual counterbalance to the church. In addition, the writing in the upper left of the picture supports this counterbalance.

In the example at the bottom, the crow prevents the minaret from tipping over visually. As the darkest value in the picture, it works against the left lean of the tower.

✳

WRITTEN ON
AuGust 23rd

HAMBURG

Tip:
The date, location, or other written comments can serve as compositional elements of your drawing. Sometimes, a date written in the sketchbook is only there to balance out the picture. Always wait until the end to place such "signatures" and choose the position carefully— it's worthwhile!

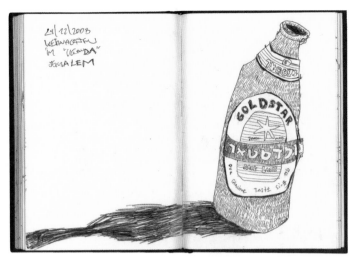

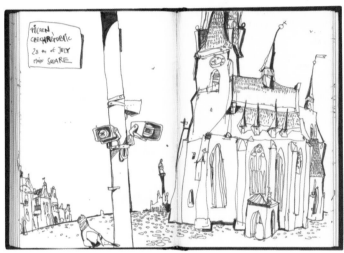

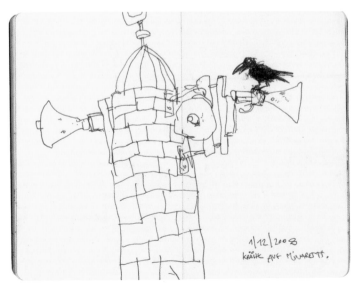

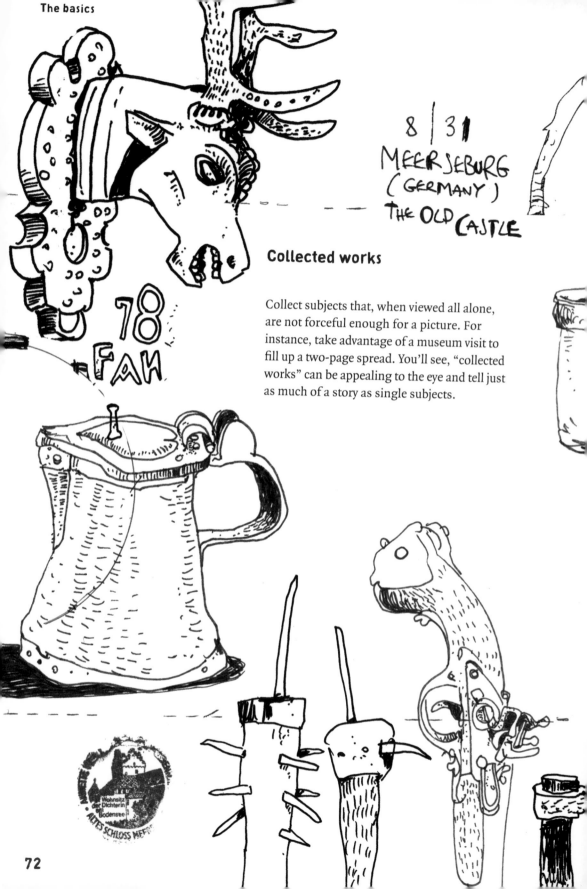

8 | 31
MEERSEBURG
(GERMANY)
THE OLD CASTLE

78
FAH

Collected works

Collect subjects that, when viewed all alone, are not forceful enough for a picture. For instance, take advantage of a museum visit to fill up a two-page spread. You'll see, "collected works" can be appealing to the eye and tell just as much of a story as single subjects.

FROM THE
'SMALL CODEX
ITALY 1394

73

Perspective

You already know the most important thing about perspective: objects closer to us look bigger than those farther away. This is a trick of the eye. The trick of perspective is transferring this phenomenon to paper. It's not all that difficult, but it took a great while before European art got the hang of it. While artists in classical antiquity were already familiar with the laws of perspective, the fall of Rome and the ancient world led to the loss of knowledge about the laws of spatial representation. Perspective was a mystery to people for nearly one thousand years. Medieval portrayals used rather peculiar solutions: vanishing points lead in all possible directions and figures—although far away—are sometimes smaller, sometimes larger. The problem was not solved until the Renaissance, with the rediscovery of ancient principles and the associated renewal of architecture.

The fact that perspective is often explained using objects and architecture is because the effect becomes more distinct through uniformity. A series of columns of the same size and at equal distances from one another also shortens visually at equal increments. Medieval cities did not possess this regularity; therefore, artists during this time did not often experience foreshortening in their daily lives.

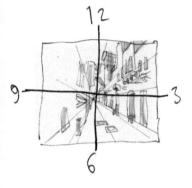

In drawing we work with vanishing points, toward which the lines in the image move. The place where all lines meet is the vanishing point. It shifts with the position of the viewer and does not need to be within the picture, but is always at eye level.

To the right is an example of a drawing with one vanishing point. On this street, the vanishing point is located roughly at the center. All of the lines in the picture head toward it. This view is called one-point perspective. We encounter one-point perspective most frequently indoors, or, as in this example, on streets.

Tip:
To ascertain the angle of a line, you can measure it as if on a clock. Take your pencil, stretch out your arm, and lead the pencil across the line. Imagine the face of a clock and thus transfer the angle ("curb at five o'clock"). Horizontal and vertical angles are provided by the edges of your sketchbook.

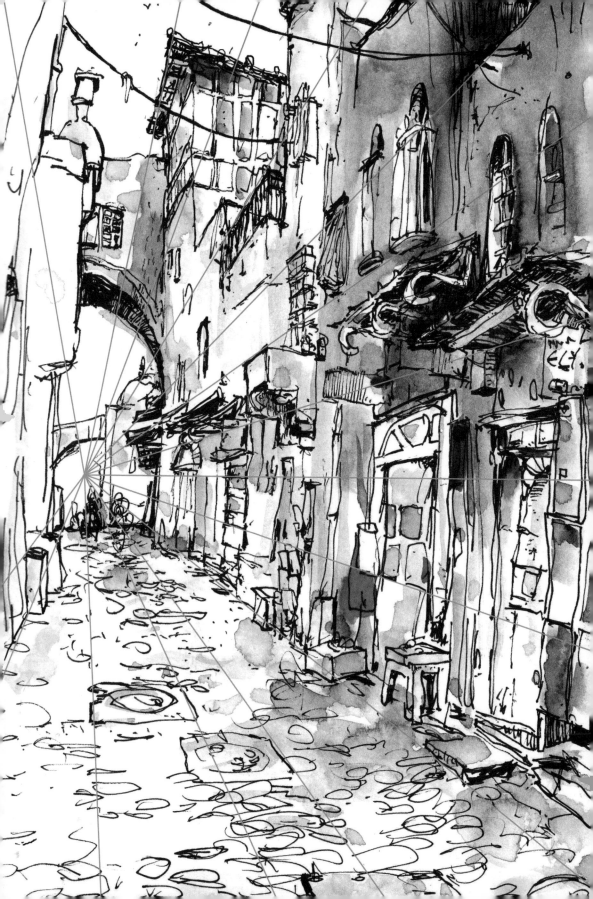

BOTTOM VIEW

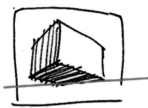

FRONT VIEW

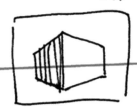

It is reassuring to know that there is no such thing as absolute perspective. It changes with your location. If you move, your perspective changes, too.

We frequently use one or two vanishing points, depending on how many sides of an object we can see. In architecture, for example, this can be two sides of a building. The two vanishing points in two-point perspective always lie on one line on the horizon and, as in one-point perspective, are always at eye level. Here, too, the view and the vanishing points change with the position of the viewer.

We see everything lying below the horizon line from above. Everything above the horizon line is seen from below. To make it simpler, remember that, in most cases, only the horizontal lines move toward the vanishing point, while all vertical lines remain static. (The exceptions to this rule are the views from very far below and very far above, the "worm's-eye" and "bird's-eye" views, respectively.)

TOP VIEW

Tip:
Shut one eye while drawing. You'll notice that drawing perspective is easier with one eye, as a two-dimensional picture can be transferred to paper far more easily than a three-dimensional one. Just make sure you always shut the same eye or the perspective will jump.

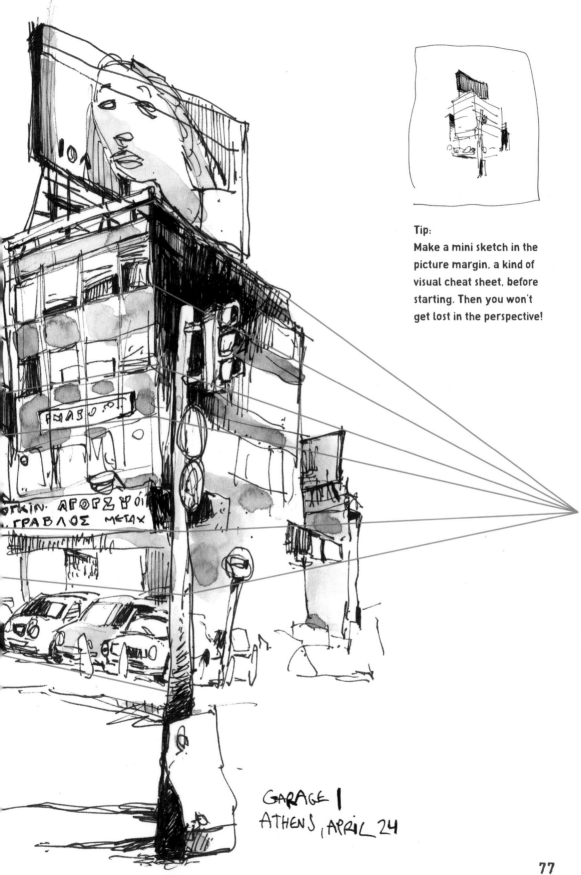

Tip:
Make a mini sketch in the picture margin, a kind of visual cheat sheet, before starting. Then you won't get lost in the perspective!

GARAGE I
ATHENS, APRIL 24

Depth and perspective

So much for theory. True, you ought to be familiar with perspective and master the basic techniques. But the most important thing in sketching is not merely the technical approach. Even a computer can construct vanishing points.

Remember, perspective is not just a construct. Depth can be depicted in many ways. You can— as shown here—also portray people in perspective. The closer they are, the bigger they appear.

You can portray depth by making the background disappear in the haze. Overlapping things— having them cover one another—also creates depth. Even colors can be used to produce visual depth. The farther away an object is, the bluer it becomes (like the blue mountains in the background).

The most important thing is that you develop a feel for depth. Don't lose your confidence. Get going and develop a sense of perspective. Truly great illustrators count on their intuition—not on technique and constructs!

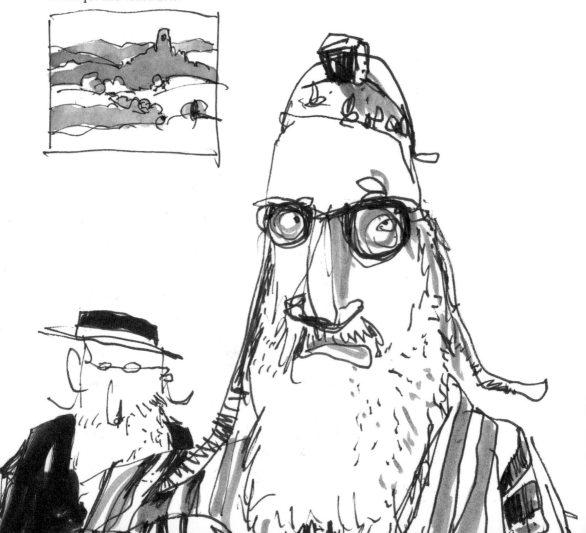

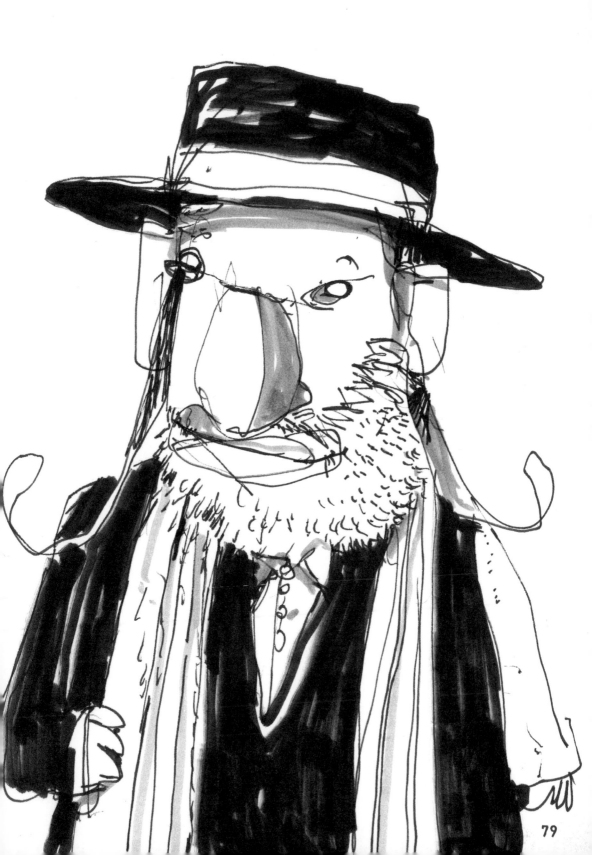

Landscapes

A landscape makes the drawing process easy for us. It doesn't pass by us or run away. Landscapes are patient. Take twenty minutes and draw a landscape.

Begin like an ant in a corner of the paper and "walk" your pencil along every pathway and every line of the area's surface. Develop your drawing from small to large, from one side to the other.

Later, when you look at your drawing, you will see how intense the process can be. You'll remember the weather, the sun, the sounds carried on the wind. Maybe you'll remember your company and a picnic, an odor, maybe the honking of cars, the chirping of insects, or the hum of a city.

Through drawing, you experience things differently. A snapshot merely documents, "I was there." A drawing creates the memory of actually being there.

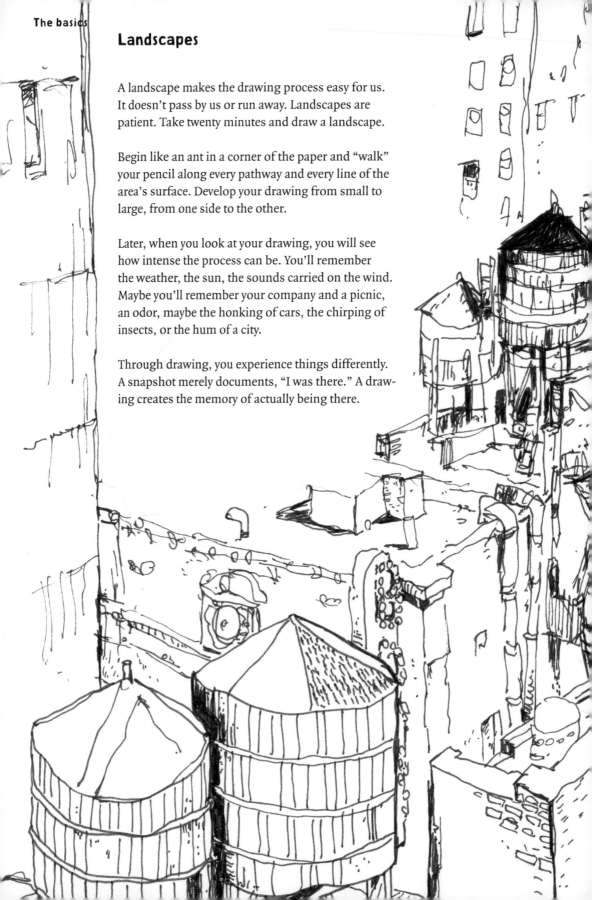

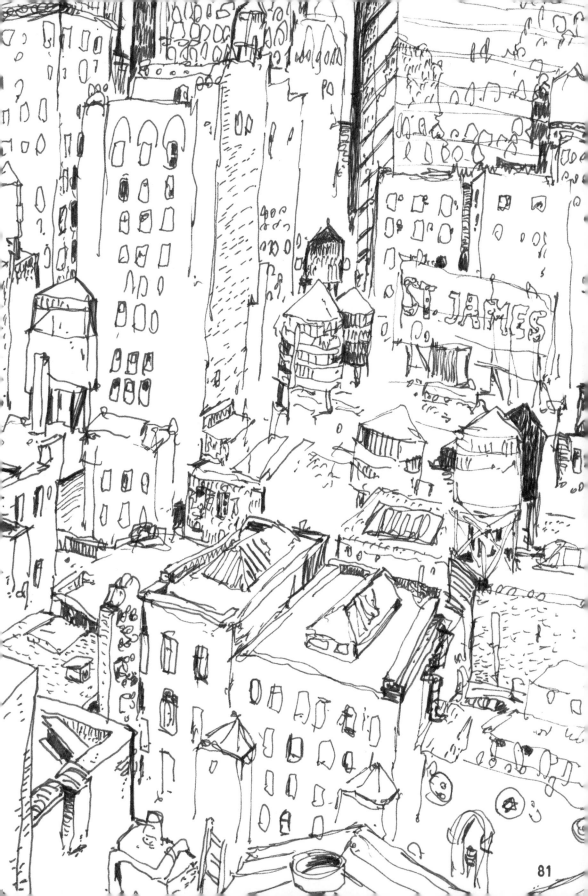

81

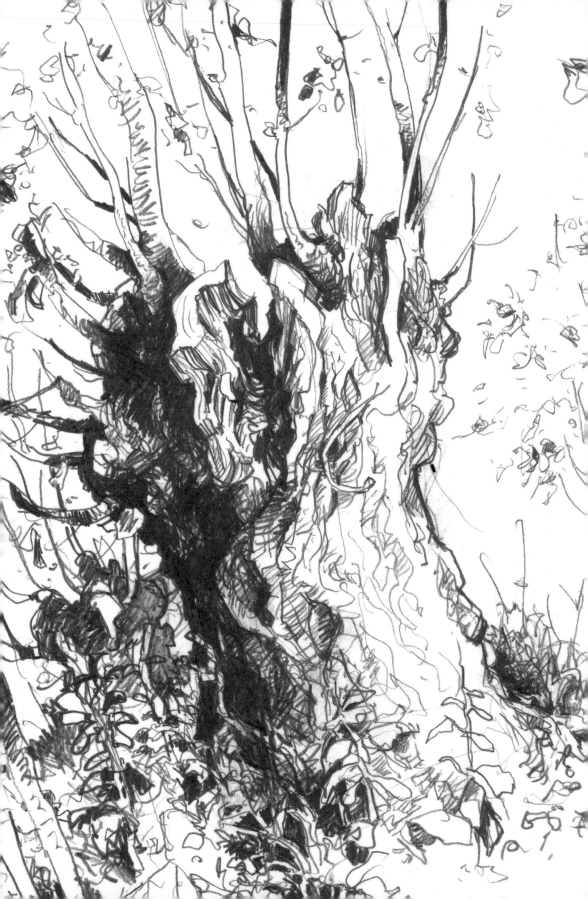

Nature

In a nutshell, the best thing about drawing in nature is being in nature! Unlike in landscape drawings, however, in nature studies we lessen the distance.

Pay attention to the specific shapes of your subjects. Study their individual aspects. Shapes and textures can be seen in trees, symmetries in flowers. In other words, you will discover design principles in nature. Ultimately, your drawings will benefit from the specificity of your observations. Incorporate these design elements into your work.

Tip:
When preparing for a drawing expedition outdoors, don't forget sunscreen, insect repellent (ticks!), and perhaps a raincoat—not to mention the picnic basket!

5:39 PM

Landscapes and time

Often, we only perceive a landscape "in passing." So why not try this: draw a travel cartoon and include the factor of time in your drawing.

Or, during a journey, draw a panel of mini sketches. For example, draw some striking views seen from a train. Supplement the subjects from memory and note the time each was seen.

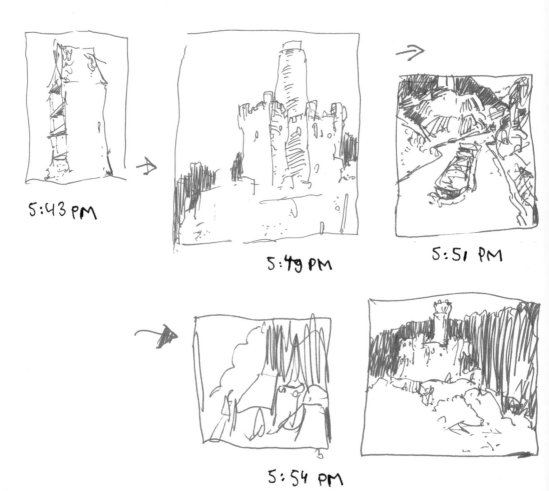

5:43 PM

5:49 PM

5:51 PM

5:54 PM

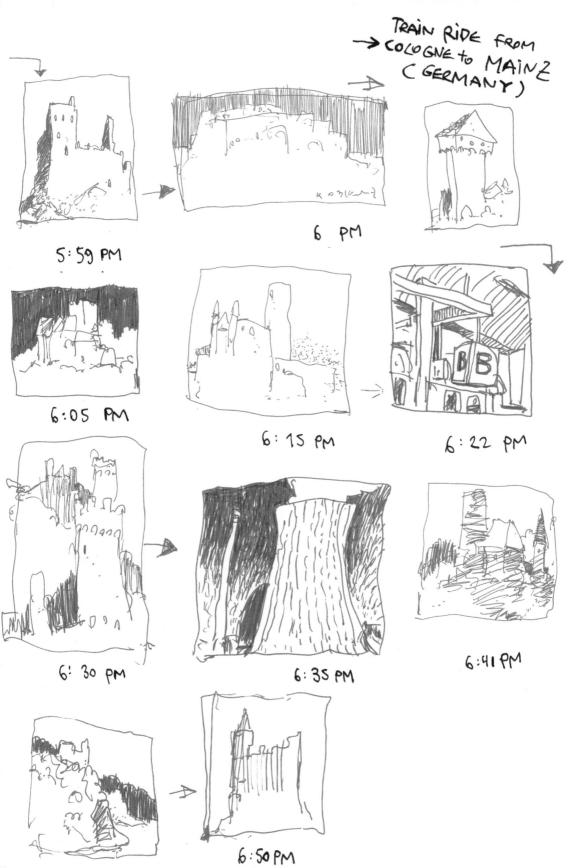

TRAIN RIDE FROM
COLOGNE to MAINZ
(GERMANY)

5:59 PM

6 PM

6:05 PM

6:15 PM

6:22 PM

6:30 PM

6:35 PM

6:41 PM

6:50 PM

85

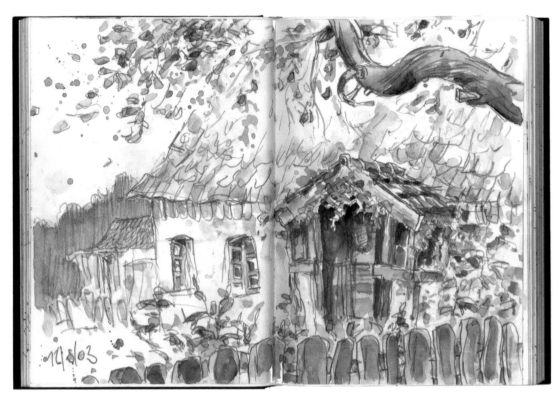

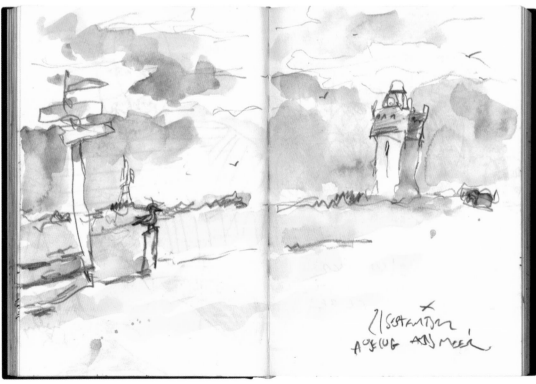

Coloring landscapes

Watercolor paints are perfect for coloring landscape sketches. The color harmonies of a landscape are essential for its atmosphere, and can be captured rapidly and confidently with watercolors.

Don't shy from landscapes just because you think they're for hobbyists. You create the sketches in your sketchbook for yourself, not for others.

Tip:
Try to include a living creature in your landscapes. Draw a bird or a cat (it will show up on its own somewhere . . .). Life breaks the stasis of your drawing.

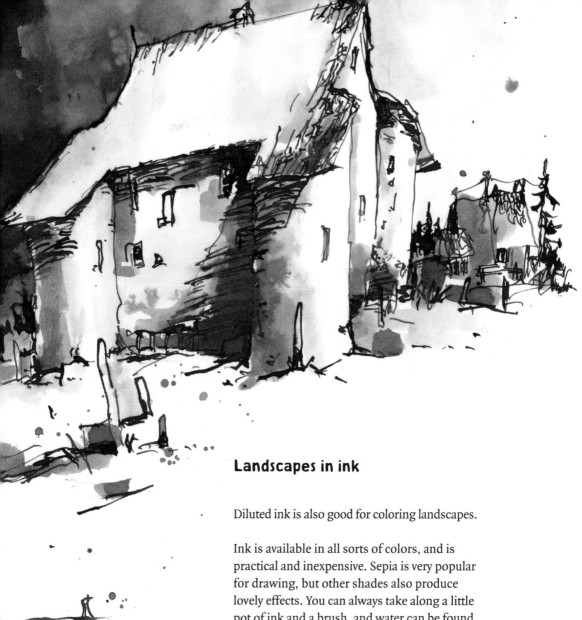

Landscapes in ink

Diluted ink is also good for coloring landscapes.

Ink is available in all sorts of colors, and is practical and inexpensive. Sepia is very popular for drawing, but other shades also produce lovely effects. You can always take along a little pot of ink and a brush, and water can be found almost anywhere.

Ink can be used both for drawing and for coloring. Diluting it with water helps produce differentiated nuances.

Tip:
In place of ink you can also use
iodine from your first-aid kit.

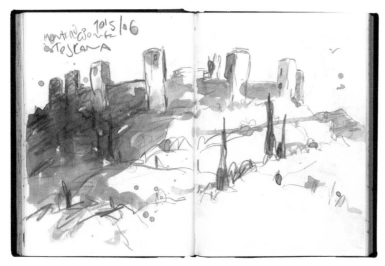

Walled town of Monteriggioni, Italy

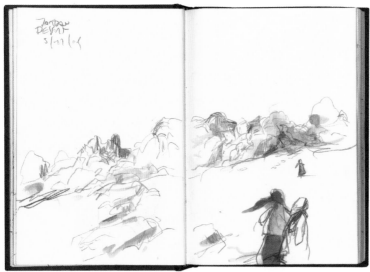

Desert near Petra, Jordan

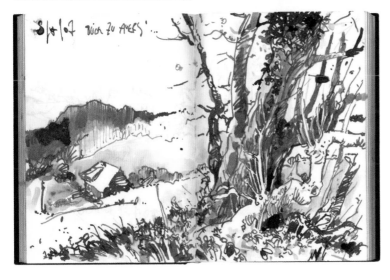

Black Forest near Freiburg, Germany

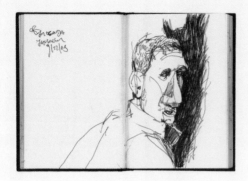

Light and shadow

Shadow is nothing more than the absence
of light.

Light consists of a blend of electromagnetic
waves that become visible where they fall
or are reflected. Where there is no light,
there is shadow. Basically, shadow is the
default, the original state.

We deal with this original state in drawing.
Oddly, we do not depict light in drawing
at all. Light is the white of the paper. The
light is already there before we begin, thus
the act of drawing means omitting the
light and creating shadows.

Shadow is at least as important as shape,
because shadows define space.

4/19/09
SANKT PAULI,
HAMBURG.

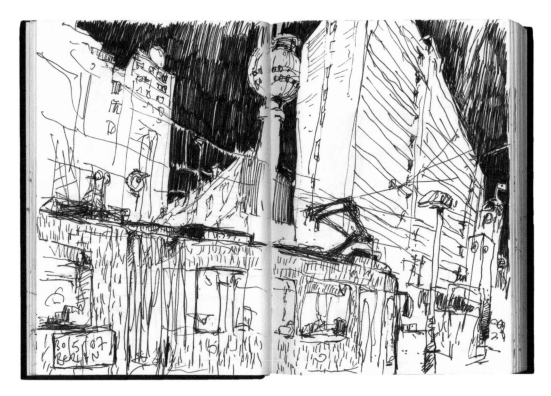

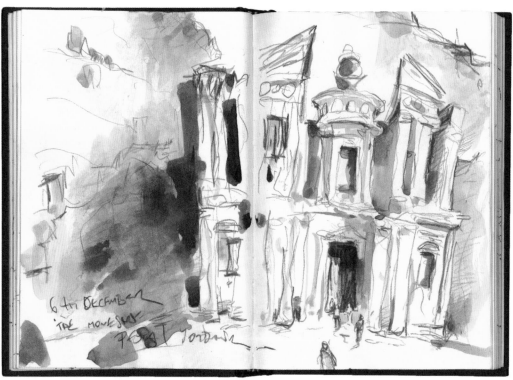

Depicting shadows

In drawing, we depict the grays of shadows with hatching—lines drawn more or less closely together that produce surfaces. They can range from very delicate grays to almost black. Hatching also enables us to convey textures and surface properties.

The second way of portraying grays is with a solid area of tone—using ink, for instance.

A combination of the two techniques is also possible, for example when you color a drawing or intensify it with a glaze.

The most important thing to realize is that what you see is light, but what you draw is shadow. Do not use it too sparingly.

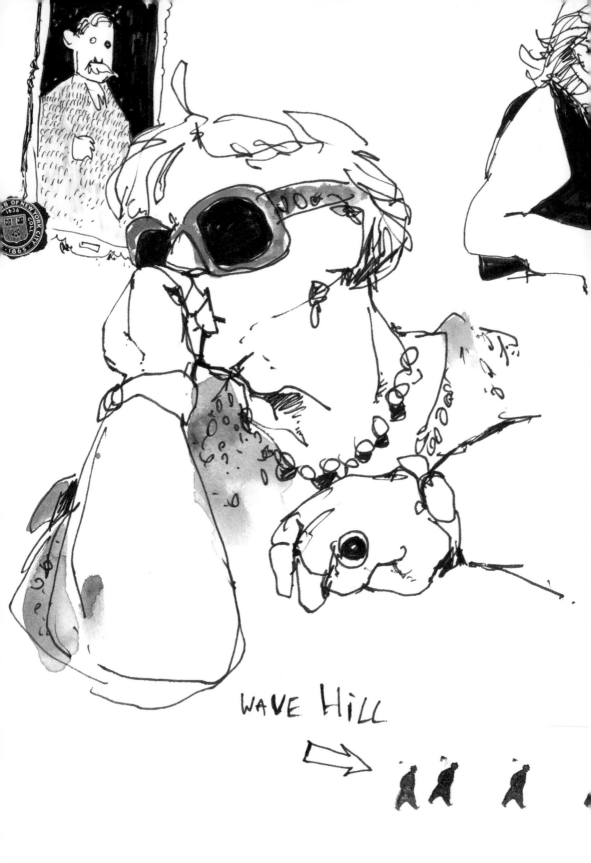

WAVE HILL

People are not objects

Drawing people is very difficult—or at least it's not very easy, right? One reason for this is that we have no distance from them. We examine our drawings of people with a far more critical eye than any other subject, since we all know what we're supposed to look like. We are so familiar with our own face, our own figure, that mistakes are far more conspicuous. In addition, people are not objects. They are living beings, individuals. People feel, people think, people move.

It's quite possible that a subject will not only move away, but may move *toward* us. Worse, they might ask, "Is that supposed to be me?"

So when we draw people we must remember that we are not only portraying them, but entering into a *relationship* with them. On the following pages I will attempt to offer a few tips for solving this dilemma.

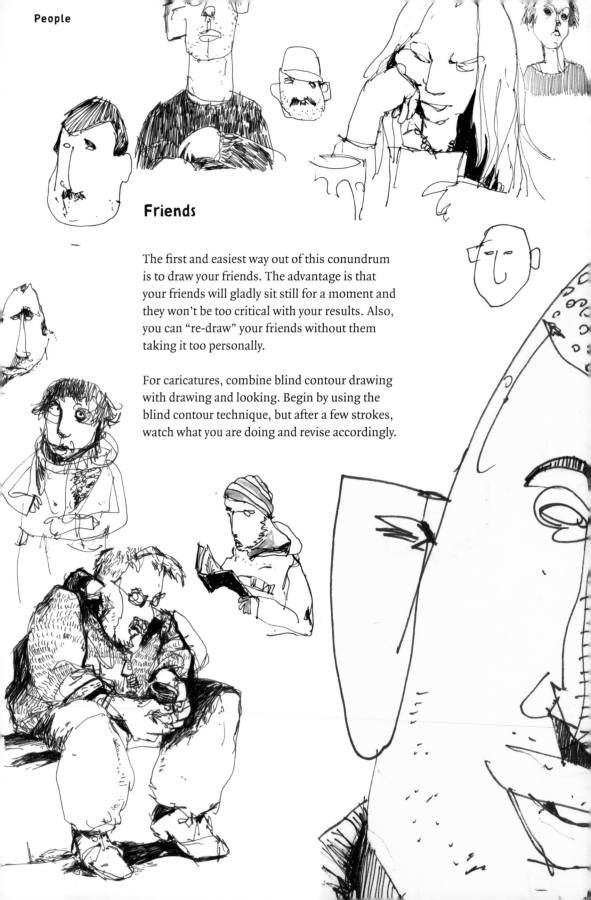

Friends

The first and easiest way out of this conundrum is to draw your friends. The advantage is that your friends will gladly sit still for a moment and they won't be too critical with your results. Also, you can "re-draw" your friends without them taking it too personally.

For caricatures, combine blind contour drawing with drawing and looking. Begin by using the blind contour technique, but after a few strokes, watch what you are doing and revise accordingly.

Passersby

As for strangers, make them your friends. Just ask if they'd mind if you do a quick sketch of them. They usually won't refuse. On the contrary, most even feel flattered and curious about the result.

However, those who are not so proud of their appearance won't necessarily thank you for documenting them. For instance, always ask beggars for permission and handle drunks carefully.

In some cases—such as with the pastor giving a sermon, shown opposite—other viewers may feel more disturbed by your drawing than the person you are portraying. Be considerate. Draw, but work discreetly!

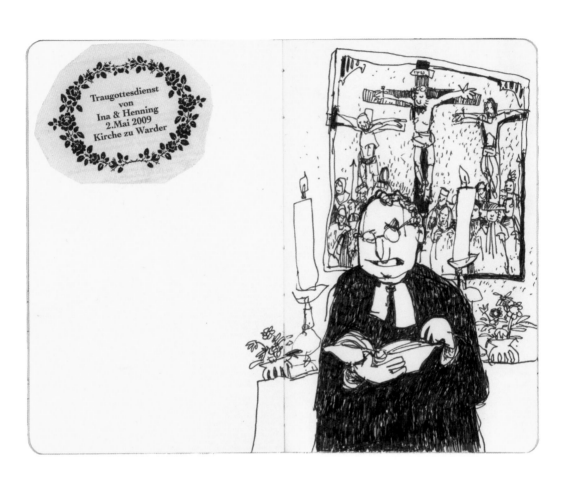

Traugottesdienst
von
Ina & Henning
2.Mai 2009
Kirche zu Warder

Tip:
Always draw a little of the surroundings
to give your subject some context.

RUSSIAN IN
ISTANBUL 11/29/08

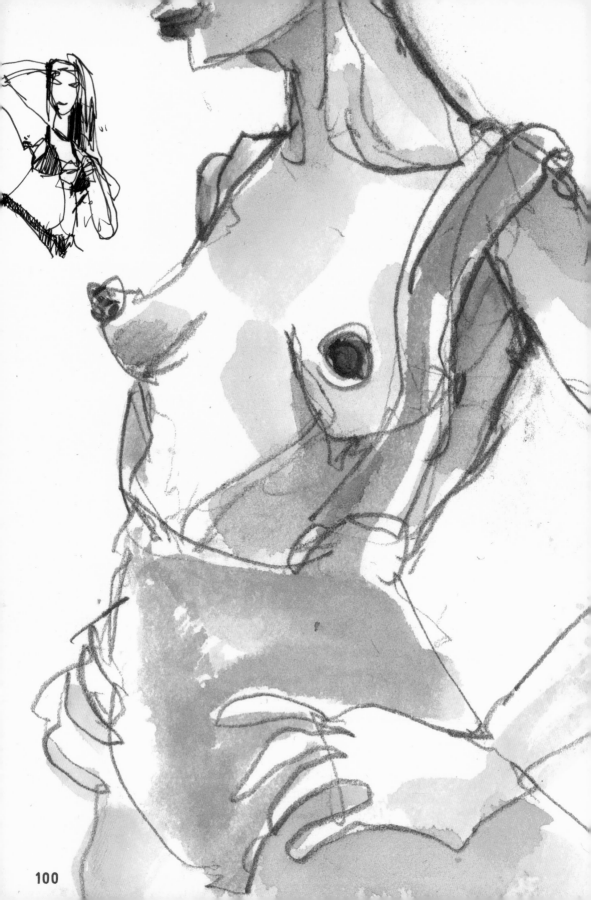

Performers

Some people work in public and deliberately put them-
selves on display. They can be rewarding to draw: they
often make good subjects and tend to be less inhibited
than most. Possible subjects include street musicians,
actors in a theater, politicians and public speakers,
ministers in a church, models, parade marchers, and
even striptease dancers.

Most of these people share a love for public display and
should have few objections to being sketched. But don't
count on it.

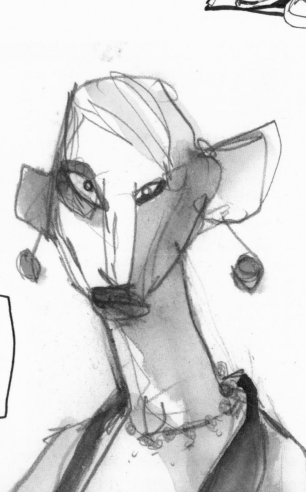

STRIPTEASE,
IN ST. PAULI
HAMBURG
GERMANY

SOLDATSM
29/11/08.

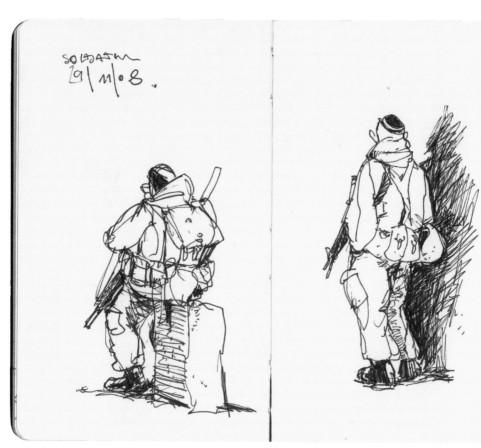

* ARAFAT MAUSOLEUM | RAMALAH + | 25 / 11 / 2008

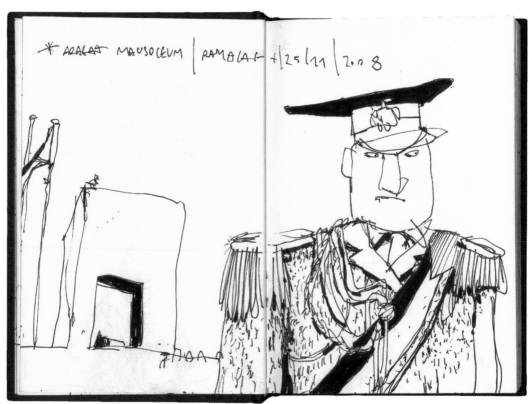

Hide and seek

Things can get dicey if you draw people who expressly do not wish to be drawn or photographed. It can be downright precarious, for instance, to draw police officers or soldiers.

The best advice here is: don't do it, or don't get caught. Keep your distance and avoid a direct line of sight if possible.

Draw from a hiding place—from a car or a store, over the shoulder of a friend, from behind a market stand, or from the shelter of a café. You can also draw your subjects from the rear.

Tip:
You can draw everywhere that photography is allowed. But this usually means the opposite as well: if photography is not permitted for security, religious, or other sensitive reasons, the same applies to your sketching.

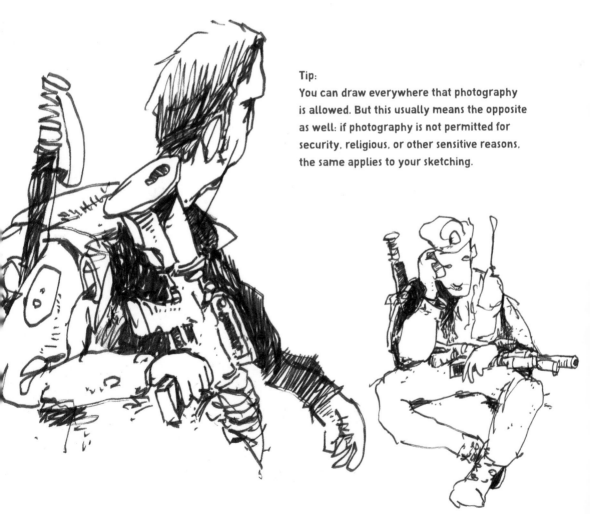

Use your head

A few years ago, I was in the Fatih district of Istanbul and was drawing a group of religious Muslims who were across the street. When they saw what I was doing, they shouted angrily at me and drew their fingers across their throats to show that they wanted to cut mine. I crossed the street to approach them and asked why they were threatening a guest in their country. We talked for a while and during this discussion, for the first and only time, I relinquished a page from my sketchbook. Better than my head.

In certain situations it's probably wise not to tempt fate. But a book about drawing cannot tell you not to draw. Instead my advice is not to get caught. The advantage of a sketchbook is that you can close it if the situation appears precarious.

Tip:
People notice when they are being watched. It's a magical thing—though in some cases, also dangerous. Do not stare at your subjects too long. Look in a different direction now and then and act as if you are interested in something else entirely. Wear sunglasses!

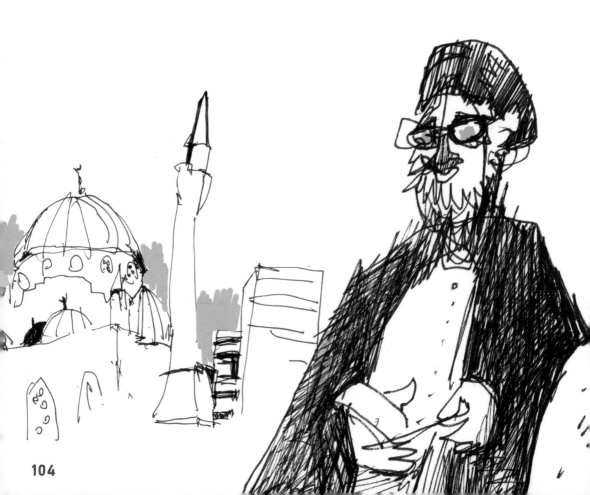

Tip:
Pay attention to the eyes and mouth. They
are more recognizable features than the
noses. Caricatures with big noses do not work
because of the nose, but *in spite* of it.

Portraits and caricature

Close your eyes for a moment and try to
describe yourself. I doubt if you will think,
"I'm the one with the big nose and freckles."
If you ask your friends to describe you, you
will hear hardly anything about your appear-
ance. Instead they may say you're a good
cook, are funny, or like *Star Trek*.

My advice, therefore, is to put that into
your drawing. You're not the one with the
big nose. Even if you have one, your nose
does not define you.

WILHELM BUSCH

The great art of caricature is to exaggerate a feature to portray a person. But drawing can do more. You can attempt to penetrate outward appearances and infuse a person's features with their inner traits. Go beyond the surface. Don't be too analytical; try to ascertain intuitively what defines the person.

One good technique for achieving this is blind contour drawing. It shortens the pathway from the eye to the hand, circumventing doubt and analysis.

Look at your subject closely and put yourself in her place. Good caricaturists are interested in people, not noses. You need to develop a closeness to the person to make a good portrait.

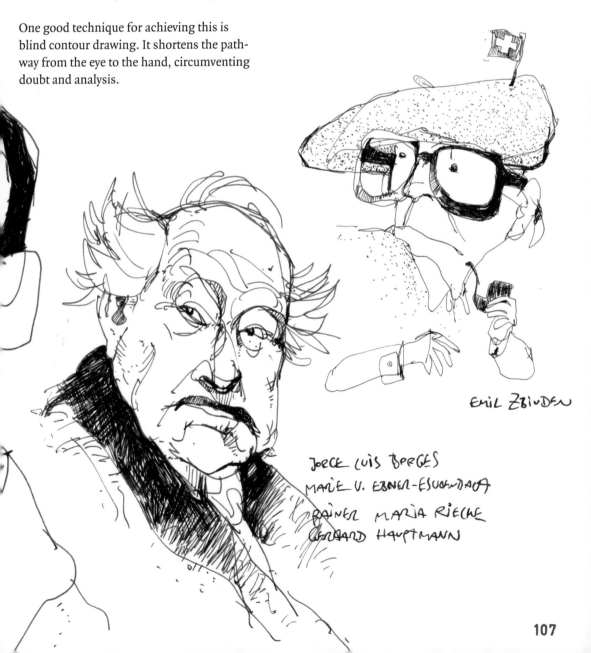

EMIL ZBINDEN

JORGE LUIS BORGES
MARIE V. EBNER-ESCHENBACH
RAINER MARIA RILKE
GERHARD HAUPTMANN

Nudes and proportion

If you type "human being" into Google's image search function the first results will not be photographs or movie stills. The first results will be drawings of people, most of all the famous study of proportions by Leonardo da Vinci from c. 1490.

Figure drawing is not very easy. There are a variety of instruction manuals for this. You are surely familiar with those wooden jointed dolls and models whose body parts are reduced to simple shapes. They can be helpful, but my personal advice is just to start drawing. Use your sketchbook and familiarize yourself with the human body through drawing. The more you draw people, the easier it will become.

You will have the opportunity to draw unclothed people more often than you'd think. Go to the swimming pool or the beach, draw your partner or yourself, and attend nude drawing courses. You'll see, nudes are fun.

In the end it will be like everything else that you learn. If it's fun, you'll do it more often. If you do it often, you'll do it well.

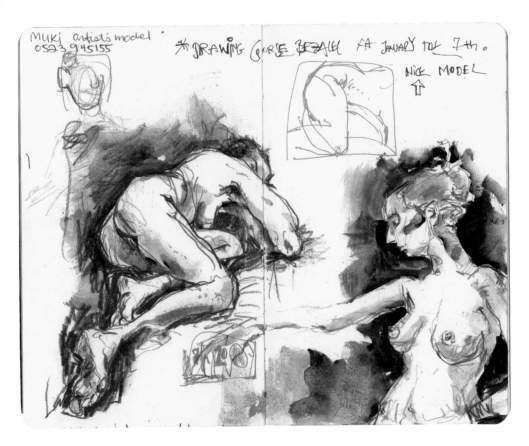

MUKi artist's model
0523 945155

DRAWING COURSE BEZALEL AA JANUARY TO 7th.

NICK MODEL
⇧

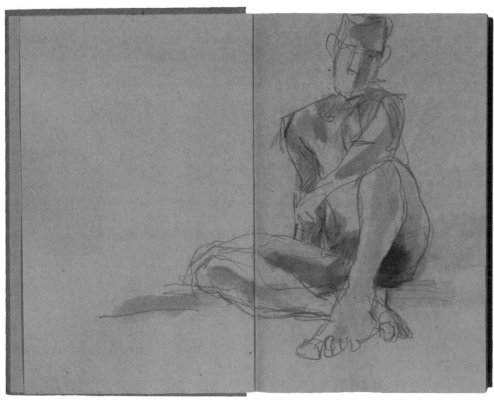

WILD DOGS
04/24/09

"It won't stop moving!"

That's the problem in a nutshell. Drawing animals may sound tricky, but it's worth it because they are outstanding subjects.

Start with animals that aren't moving. They can be sleeping animals (your cat) or dead animals (a mouse that your cat "presented" to you). There are also lazy and slow animals, like turtles and snails.

At the start you can even use "stuffed" animals. Every large city has a natural history museum full of specimens—the ideal place to make your first attempts at drawing animals.

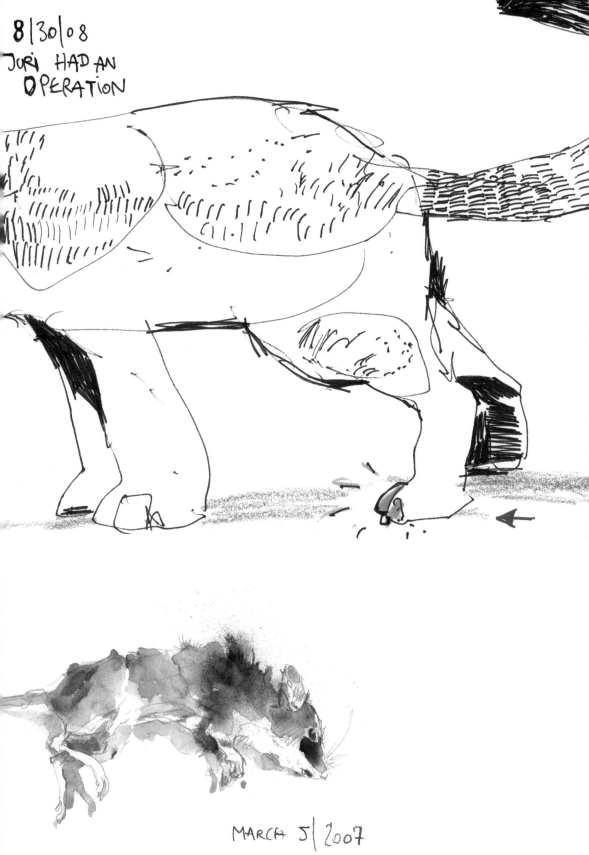

8/30/08
JURI HAD AN
OPERATION

MARCH 5/ 2007

111

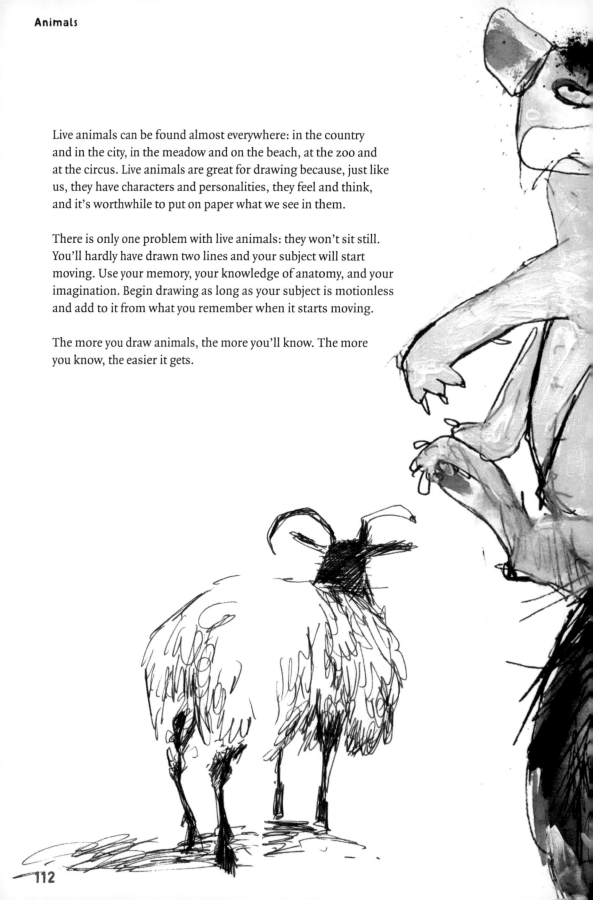

Live animals can be found almost everywhere: in the country
and in the city, in the meadow and on the beach, at the zoo and
at the circus. Live animals are great for drawing because, just like
us, they have characters and personalities, they feel and think,
and it's worthwhile to put on paper what we see in them.

There is only one problem with live animals: they won't sit still.
You'll hardly have drawn two lines and your subject will start
moving. Use your memory, your knowledge of anatomy, and your
imagination. Begin drawing as long as your subject is motionless
and add to it from what you remember when it starts moving.

The more you draw animals, the more you'll know. The more
you know, the easier it gets.

Tip:
Work quickly while your subject is
sitting still and always begin with the
most important thing: the pose. You can
always add the texture of the fur long
after the animal has disappeared back
into its den.

New and old places

Why do we draw Tuscan farmhouses? Why picturesque villages? Why sprawling castles on the Rhine? One answer is that they are so lovely and romantic. This is true, of course.

But why are they lovelier than a suburban development in New Jersey? Why do hosts of watercolorists always paint Tuscany and not a mall in Wisconsin?

The answer to this question is a little bit complicated. In his own time, Rembrandt's windmills were not depictions of the "good old days," but the latest state of the art, and Dürer's castles were his contemporaries. Basically, the artists then painted wind power plants and buildings. So why is it so curiously difficult for us today to let go of the same old subjects and paint modern ones instead?

Of course, Tuscany is beautiful. Yet all too often, our perception of "beauty" means "familiar"—in other words, others already found it "beautiful" and it is therefore a subject that is *allowed* to be painted.

The Romantics sought out these subjects, not because they appeared beautiful to them, but because they meant something. The retrospection of the Romantic period was, in fact, related to a yearning for better days, for mystery, and an escape from the oh-so-dull everyday.

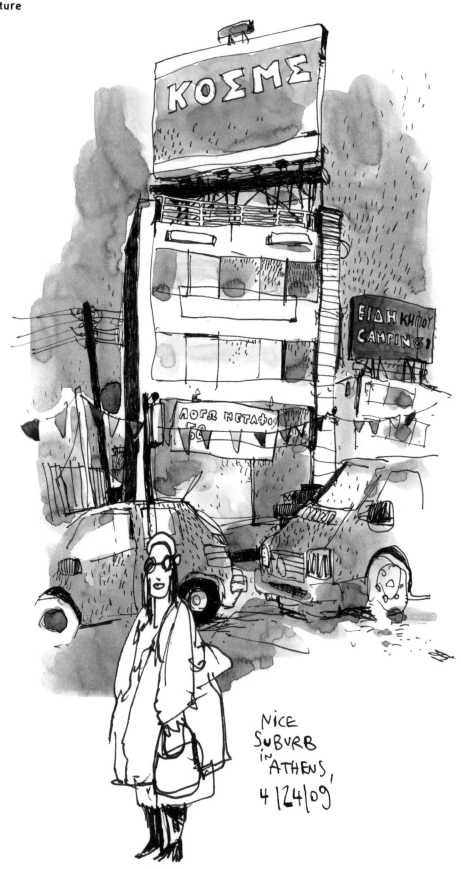

Consider the everyday

The age-old questions remain quite relevant: why do we still climb up to the mountains? Are they beautiful because they mean something to us? Because they offer history, romance, a subject? Because they meant something generations ago? Paintings tend to degenerate to postcard views.

If your goal is actual documentation, you'll notice that more contemporary landscapes are characterized by home improvement stores than by windmills. So when drawing, ask yourself, what does the subject mean to you personally? Search for a unique appeal. If the result is an ancient temple—fine. But you ought to be just as content painting an interesting bus stop in Dallas.

It's your sketchbook—you decide what to fill it with.

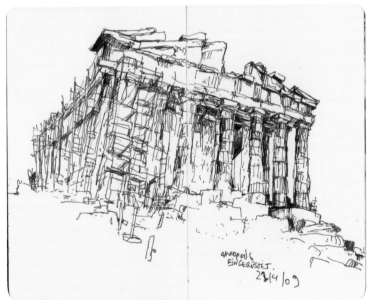

Drawing buildings

How can you get such a big building on such a tiny sheet of paper—and do it right? No need to panic. It's not that hard.

With architecture, you are mainly dealing with perspective drawing. It's like drawing a shoebox: find two vanishing points, employ foreshortening, etc. But with buildings, lots of minor details tend to distract us. There are doors, windows, corners, and angles everywhere, and all of these details themselves follow laws of perspective. If there are round shapes, too, like arches or cornices, confusion is boundless and you'll soon want to just throw down your pencil.

It's understandable. No other art form has changed the appearance of the world more than architecture, and no art form is more likely to outlast us. It's not surprising, then, that it demands so much respect.

My advice is to shrink the subject to shoebox size. Once you imagine a miniaturized rough shape, everything will get easier. First take care of the lines without all the details. Try to see your house as a big cube. Then transfer the basic shape to your page and add the details at the end. This process will squeeze that building perfectly into your sketchbook.

Tip:
Don't forget that you're just sketching the building—not constructing it. So don't meticulously count every window; you can polish up the details once you've basically captured the overall shape.

9/13
REEPERBAHN
HAMBURG

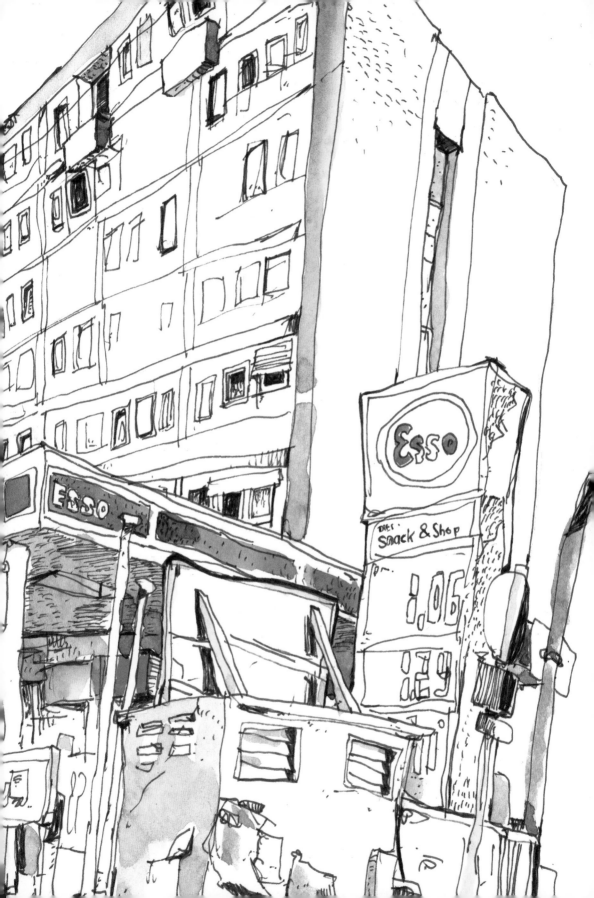

Stay open

Can mundane places produce special drawings? Can special places produce outstanding drawings?

Of course, you can draw anywhere—no matter whether a place is spectacular or inconspicuous. What's important is that it is interesting to you personally. Open yourself to the place, appreciate it, and your drawing will reflect your affections. Perhaps it won't exactly capture the way it looks objectively—that's a job for photography—but the way it looks to you. That's what counts.

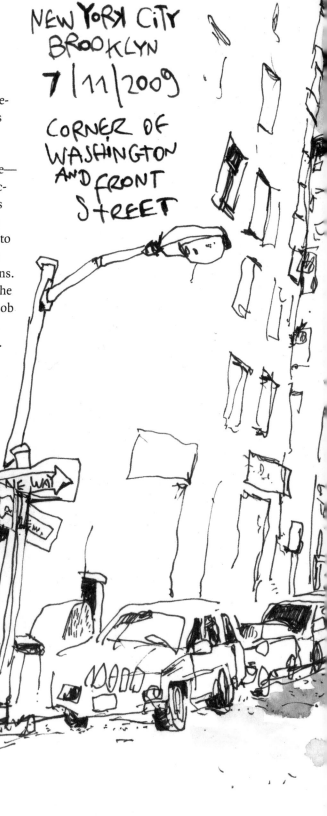

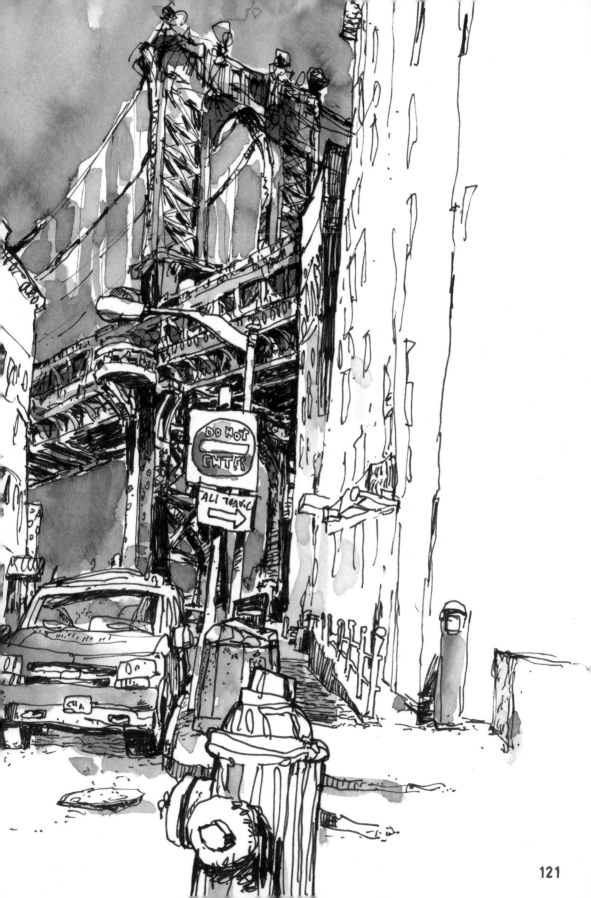

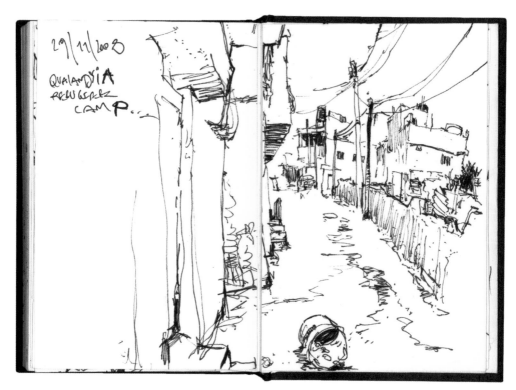

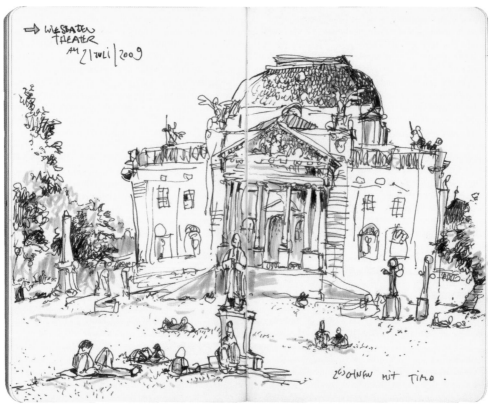

Good and bad places

Where and what an artist draws makes a big difference. You'll have to adjust yourself to very different outward circumstances if you draw in a peaceful park versus a precarious or dangerous place. In order to open up to a place, you must also ponder where and when you can draw.

The double-page spread shown opposite, top, was made in a refugee camp in the Middle East. I was only able to draw because I was traveling with a journalist and a guide who informed the local militia about me— but it was still a threatening situation. By contrast, I sketched the state theater in Wiesbaden, Germany, shown opposite, bottom, during an hour off from class on a sunny day.

You have to adjust yourself to places, for good or for bad. The rule for journeying artists: don't go to dangerous places indiscriminately and don't go to unsafe places unprepared.

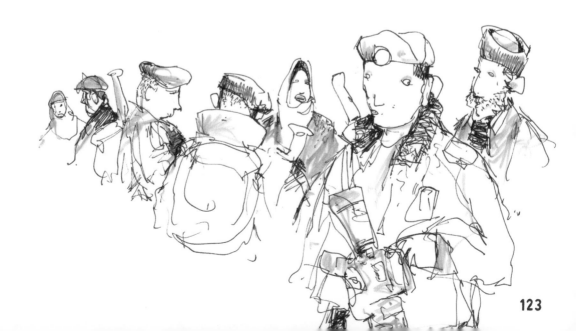

LAPIS BLUE

LEAF GREEN

BURNT SIENNA

NAPLES YELLOW

Finding your spot

Before you begin, take time to carefully seek out a place to work.

Think about what technique you plan to use while sketching. If you plan to color a drawing, you'll need more time than if you only plan to work with a pen or pencil. Make sure you will be able to comfortably stay at your workplace for a while. Don't sit down on pathways that are traveled on, and avoid uncomfortable, cold, or windy spots as well as places where you feel you can be observed. It's best to find a place where no one can stand behind you; ideally, against a wall.

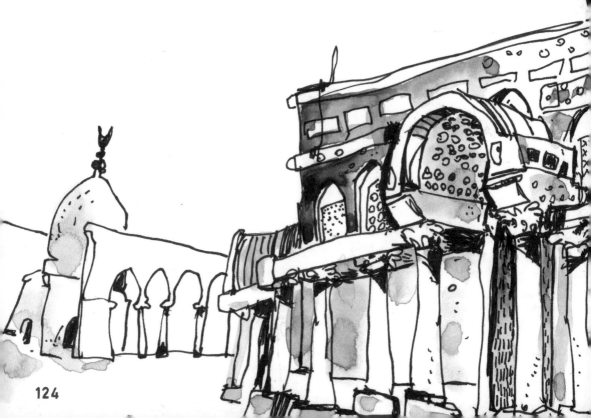

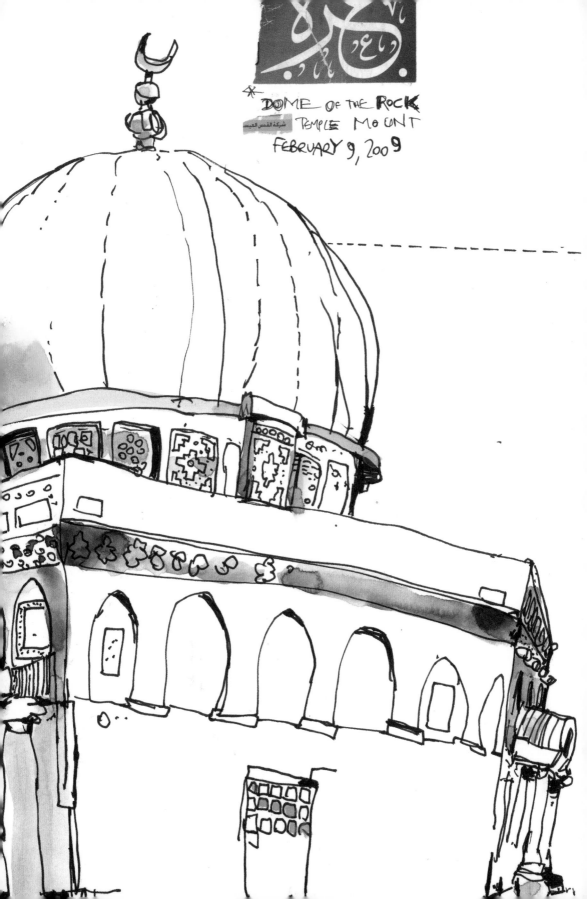

DOME OF THE ROCK
TEMPLE MOUNT
FEBRUARY 9, 2009

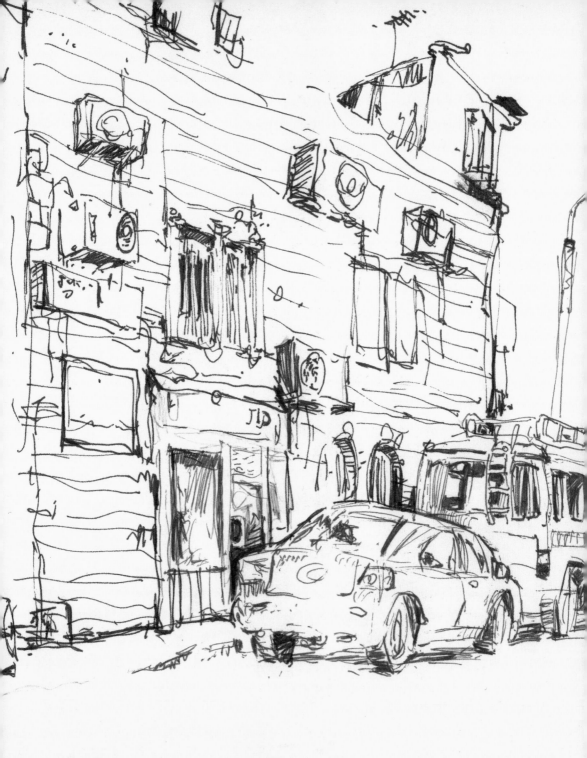

JANUARY 17, 2009

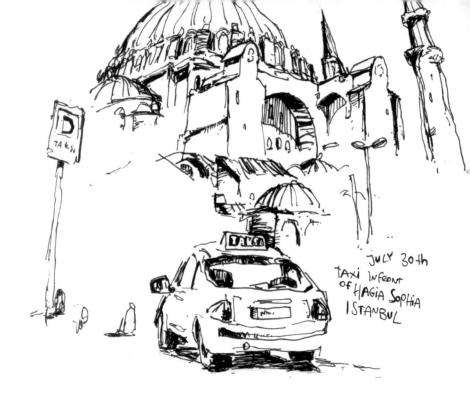

JULY 30th
TAXI INFRONT
OF HAGIA SOPHIA
ISTANBUL

Don't forget to draw the cars

As obvious as it may sound: draw the cars!

If you imagine a picture of a mosque in Istanbul and then compare that with what you actually see there, you'll notice one decisive difference: the cars are missing in your imagination! We all have several images, films, and photographs in our minds that characterize our idea of the world. When drawing, we lug boxes full of travel sketches, drafts, and illustrations by earlier generations of painters around with us—romanticized pictures, most of which were made *before* the advent of the automobile.

Today, though, places look different. So don't trust the drawings of earlier generations; trust your own eyes. Draw the cars. Draw the billboards, the air conditioners, the traffic signs . . . draw your era!

This attitude will help you discover what is actually in front of you, rather than only seeking whatever is similar to the images in your mind.

Old pictures describe old times. Describe your own!

Cars mark the era

One more remark about automobiles: cars are like a time stamp for your sketches.

We all know exactly what car belongs in what place and in what time. A sleek sports car belongs in the 1960s and an environmentally friendly hybrid in the present. The cars in your drawings (similar to traffic signs) show exactly where and in what year your drawings were produced.

We may not always be mindful of it, but the present that we capture today will very soon be surprisingly long ago. That is a good reason to capture it (and its cars) faithfully.

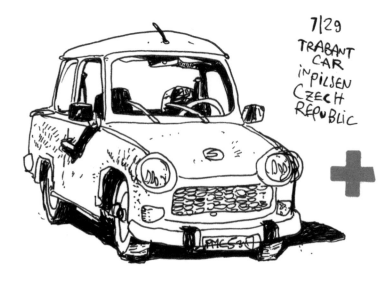

7/29
TRABANT CAR
iN PILSEN
CZECH
REPUBLIC

ONE

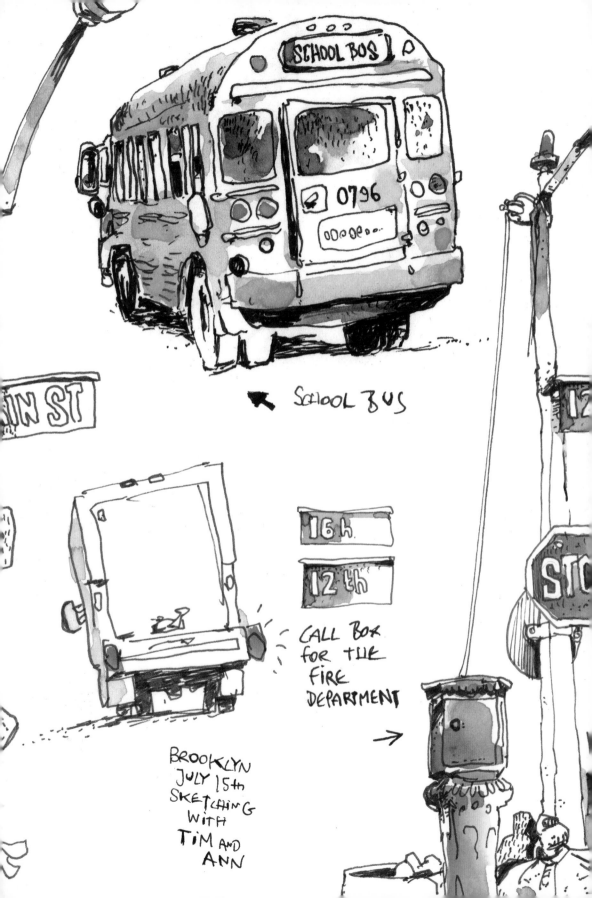

SCHOOL BUS

0796

SCHOOL BUS

IN ST

12

16 h.

12 th

STO

CALL BOX
FOR THE
FIRE
DEPARTMENT

BROOKLYN
JULY 15th
SKETCHING
WITH
TIM AND
ANN

Montages

Tip:
Emphasize important
aspects by using color.

Photographs are most suited for moments,
drawings for montages.

Use your sketchbook to illuminate more
than just one angle of a place. Capture what's
around you on one page. Draw vistas. Fill
up a two-page spread with a variety of views
and inhabitants of a place. Link spatial and
chronological aspects in one view and tell
a story with it.

You'll see, montages tell far more than
single shots.

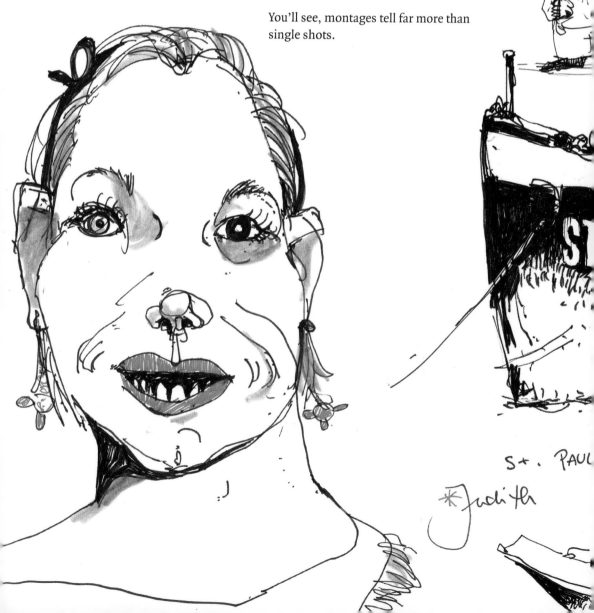

St. PAUL

Judith

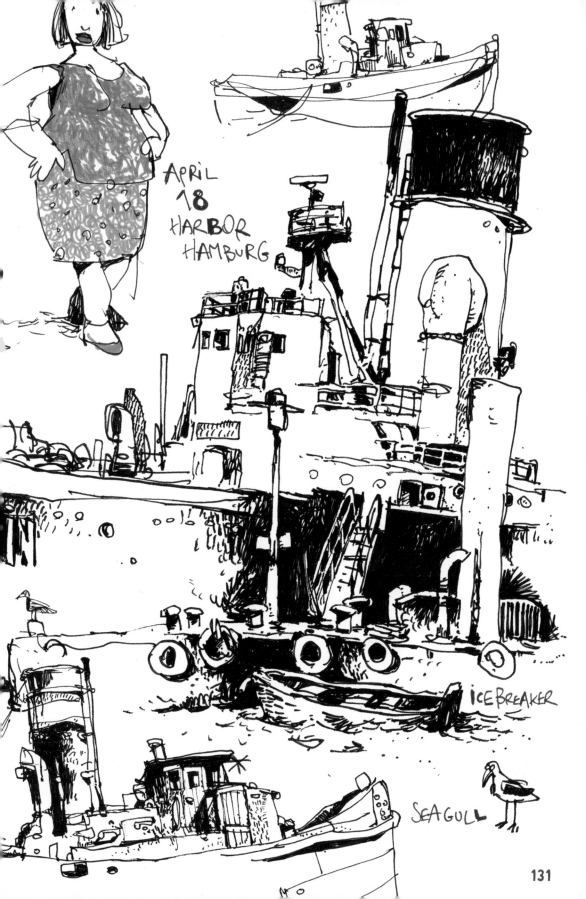

APRIL
18
HARBOR
HAMBURG

ICEBREAKER

SEAGULL

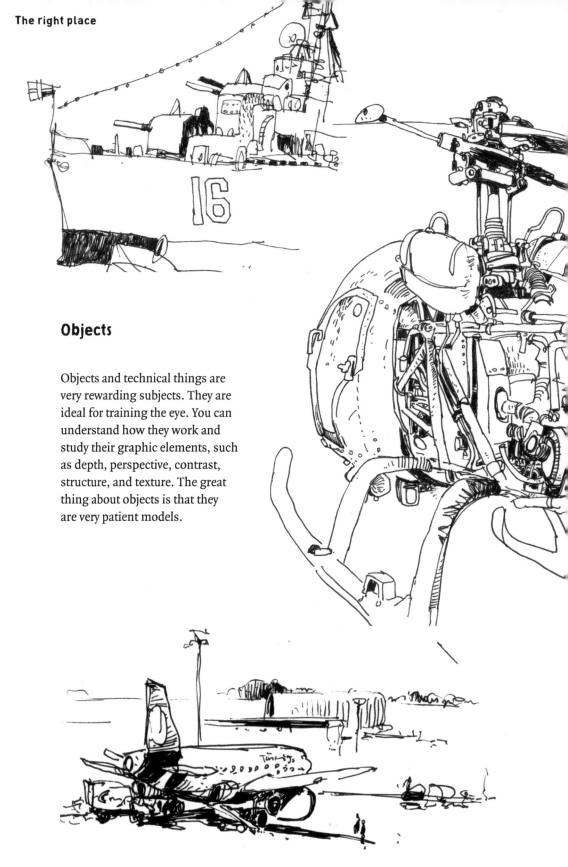

Objects

Objects and technical things are very rewarding subjects. They are ideal for training the eye. You can understand how they work and study their graphic elements, such as depth, perspective, contrast, structure, and texture. The great thing about objects is that they are very patient models.

The problem with objects, however, is that technical drawings in particular often only have a superficial appeal. As fascinating as they may be at first glance, they can become quite soulless and boring at second glance. To make things interesting, you must therefore understand something fundamental: objects are usually only interesting *in reference to us*.

Without people, objects are not at all imaginable. An object needs an author, a creator, as much as someone who uses the object. That is why the depiction of an object should always include a reference to a person. For instance, you can capture the abstract term "loneliness" by portraying an object, simply because the object by itself—say, a tipped-over chair— indicates the absence of people.

As artists, this means that we not only illustrate objects, but can also tell stories with them. This is where objects stop being just things.

Tip:
If you're wondering how to portray something in a lively way so that it is interesting for viewers, the answer is simple: you yourself have to find it interesting!

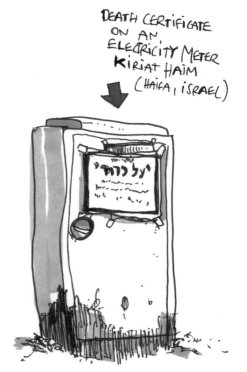

DEATH CERTIFICATE
ON AN
ELECTRICITY METER
KIRIAT HAIM
(HAIFA, ISRAEL)

4|2|2008 Sienna

When in Rome, see what the Romans see

This much is certain: it's always better beyond the blue ridge of hills on the horizon than it is here. Being on the go is part of being human. It's not for nothing that so many stories begin with a journey, that we are often on the move during summer (the "best time of the year"), and that "all of life is a journey."

Sketchbooks are primarily travel books. They are journals and books of hours, in which we do not work in our usual surroundings, but reflect on what is outside, what is foreign.

Sketchbooks are not only suitable for drawing; we capture memories in sketchbooks, jot down addresses of holiday acquaintances, and stick interesting-looking bus tickets in them. A sketchbook is a laptop with no cables, ready and waiting to hold our sights and moments.

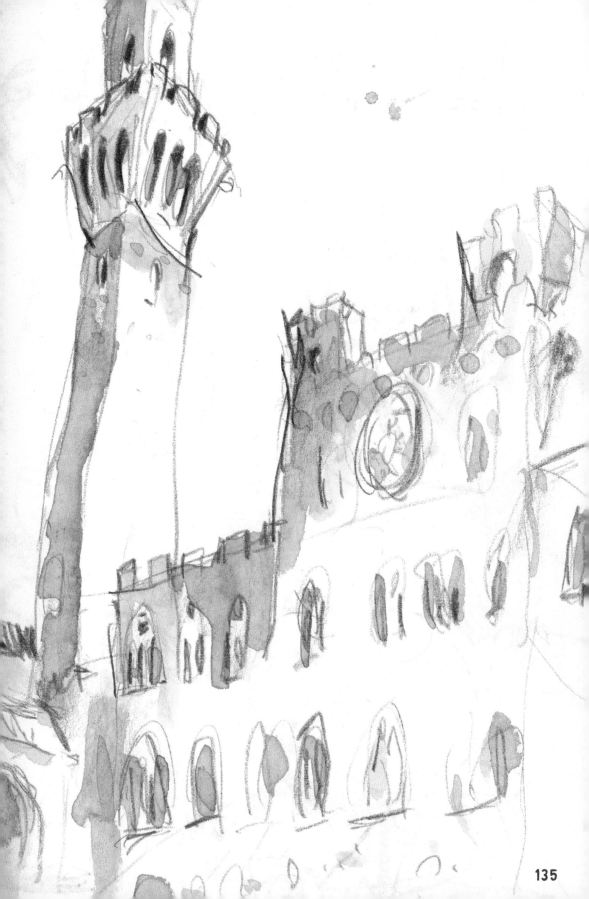

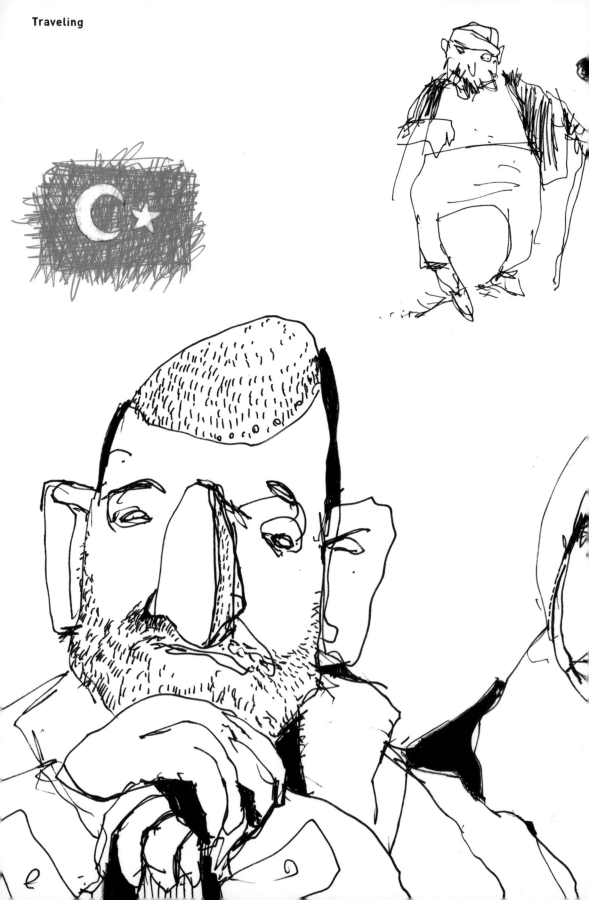

Travel drawings

Snap—that was one second.
Snap, snap—that was two.

Foreign countries are fantastic and fascinating.
They certainly earn more than two seconds of
your attention. When you draw impressions
in a foreign land, it's only natural for you to
deal with your subject for longer than it takes
to snap a photo. Your subjects will thank you
for it.

People recognize quite clearly the difference
between genuine interest and touristy tally-
ing up. When you draw in foreign countries,
you'll have a whole different approach to
conversations with the locals (even in coun-
tries where making images of people may be
frowned upon). By drawing something and
intensively grappling with it you signal
genuine interest. Interest is almost always
rewarded. Perhaps it's with a smile, a chat,
or a cup of tea—regardless, it will be a
moment that will stay with you.

LEECHES (!)

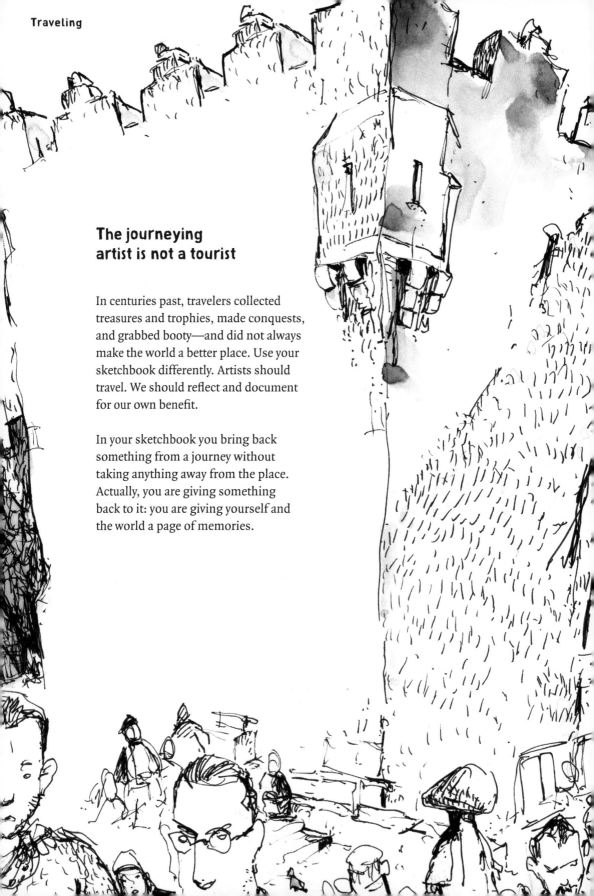

The journeying artist is not a tourist

In centuries past, travelers collected treasures and trophies, made conquests, and grabbed booty—and did not always make the world a better place. Use your sketchbook differently. Artists should travel. We should reflect and document for our own benefit.

In your sketchbook you bring back something from a journey without taking anything away from the place. Actually, you are giving something back to it: you are giving yourself and the world a page of memories.

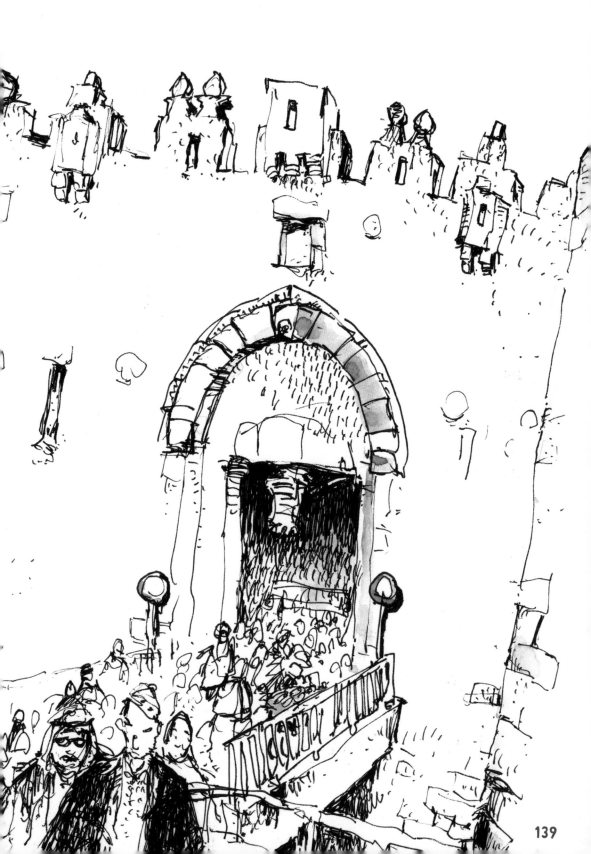

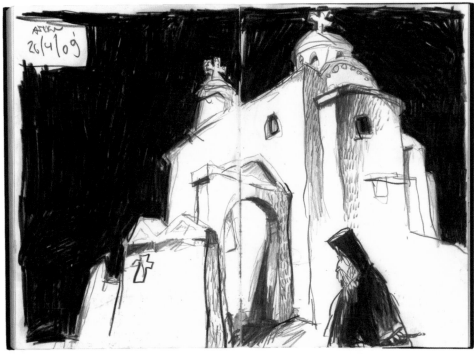

Drawing is a global language

Even if you don't speak the local language, drawing is a global language. Pictures are the beginning of all language; they are understood without any words or syntax. Drawing is communicating. Scribbling a bed or a loaf of bread on a scrap of paper overcomes any language barrier.

Maybe that is one reason pictures are revered—but also are taboo—in so many cultures. Aniconism—the prohibition of pictures—is a kind of language ban, a ban on dialogue between different cultures. Be aware of this issue when you are drawing while traveling. Pictures can burn bridges just as easily as they can build them. Much that we find fanciful is real life to the locals, and part of their identity.

So don't behave like a paparazzo. Be aware of what is allowed and what is not and do not hurt the feelings of your hosts. In case of doubt, do not let go of your book, and when asked, show something neutral.

Tip:
One good trick is to draw different subjects on either side of a double-page spread. For instance, draw a street scene on the right-hand page and figures on the left. Use a loose sheet as a cover and slide it over the page with the figures if anyone takes a look.

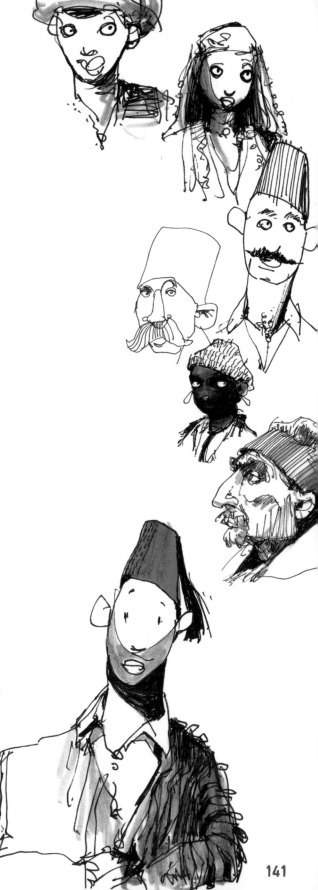

The right place
at the right time

You know the truism that you can be in the wrong place at the right time (and vice versa)? Both have to fit together to be right for drawing.

When crowds of people are pushing through your view, you'll enjoy sketching as little as if you were in a rainstorm or in the cold (though I did once use vodka to watercolor in a Polish winter because it doesn't freeze as easily as water . . .). You not only need the right place, but also the right time.

It is, therefore, wise to make a note of a place and return when it is more convenient. Wait for a sunny day, the right light, or for the tourists to go to bed. Remember, you need a quiet spot for drawing.

For a change of pace, try an unusual time of day. Some places can only be drawn at seven in the morning.

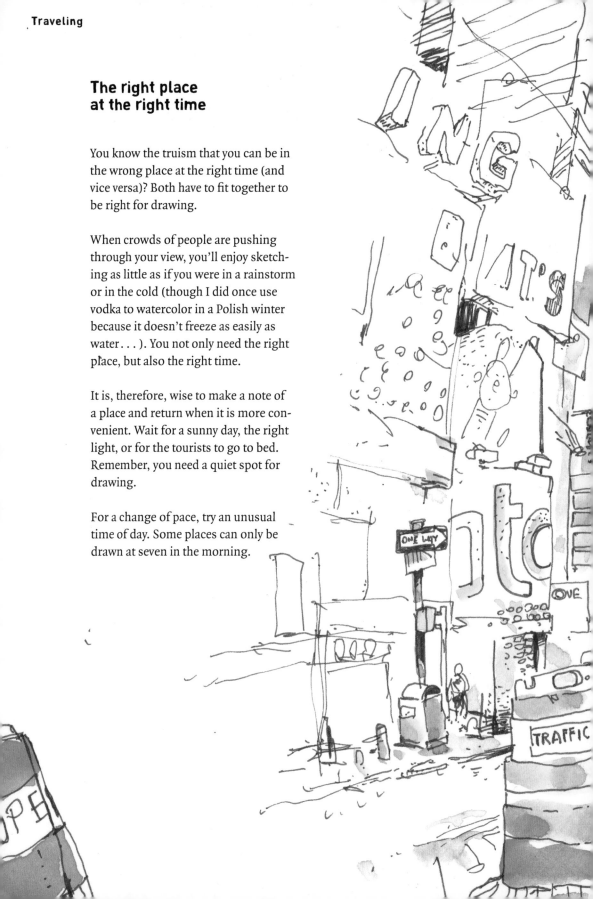

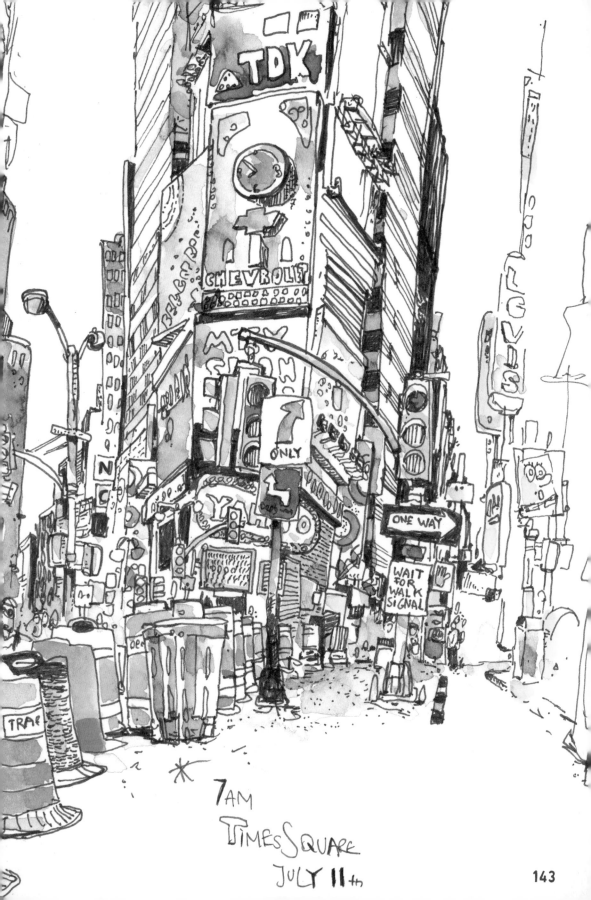

7AM
TIMES SQUARE
JULY 11th

143

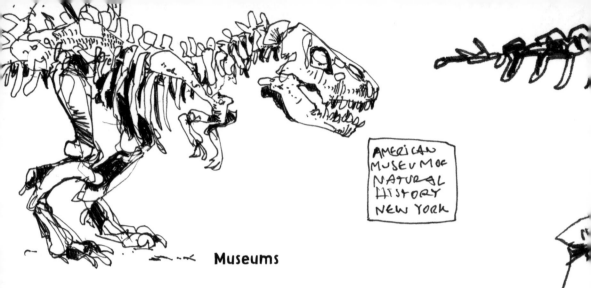

AMERICAN MUSEUM OF NATURAL HISTORY NEW YORK

Museums

Nothing is more likely to spoil your drawing than rain.

So use a rainy day—especially when traveling—for a trip to the local museum. From small local history and folklore museums to large international collections, almost all museums offer something worth drawing. Old museums in particular offer a fascinating atmosphere and exciting glimpses into the past. Of course, it is also a good opportunity to learn something.

7/28
GHOST MUSEUM
PILSEN/CZ

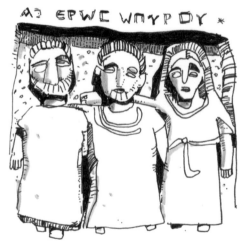

AƆ EPWC WⵔYP ⴲY *

* GRAVE RELIEF EARLY 2ND CENTURY A.D.
 BENAKI MUSEUM ATHENS

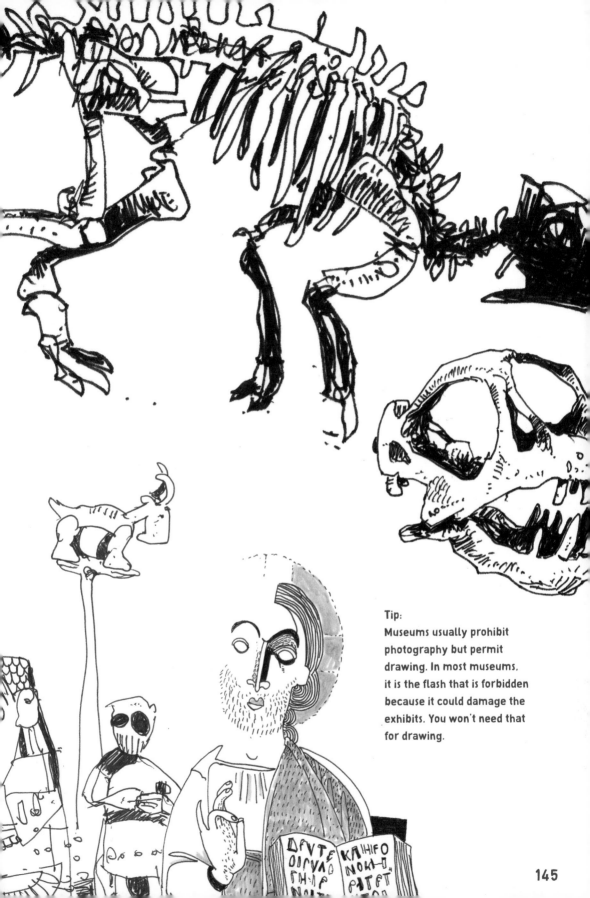

Tip:
Museums usually prohibit
photography but permit
drawing. In most museums,
it is the flash that is forbidden
because it could damage the
exhibits. You won't need that
for drawing.

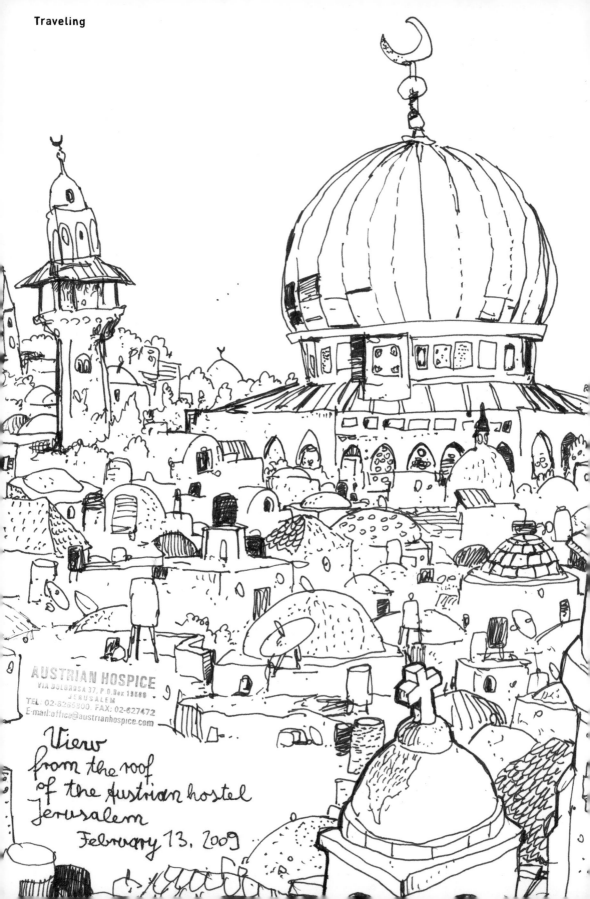

AUSTRIAN HOSPICE
VIA DOLOROSA 37, P.O.Box 19000
JERUSALEM
TEL: 02-6265800, FAX: 02-627472
E-mail:office@austrianhospice.com

View
from the roof
of the Austrian hostel
Jerusalem
February 13, 2009

Panoramas

Draw from high above. You can almost always find a place from which you have a panoramic view. Look for a nearby hill, a tower, or a high building and draw from there.

Tip:
For urban panoramas, always start with a large building in the foreground and use it to gauge the sizes of the surrounding buildings. Shut one eye and measure ("the dome on the left is as high as seven steps on the staircase").

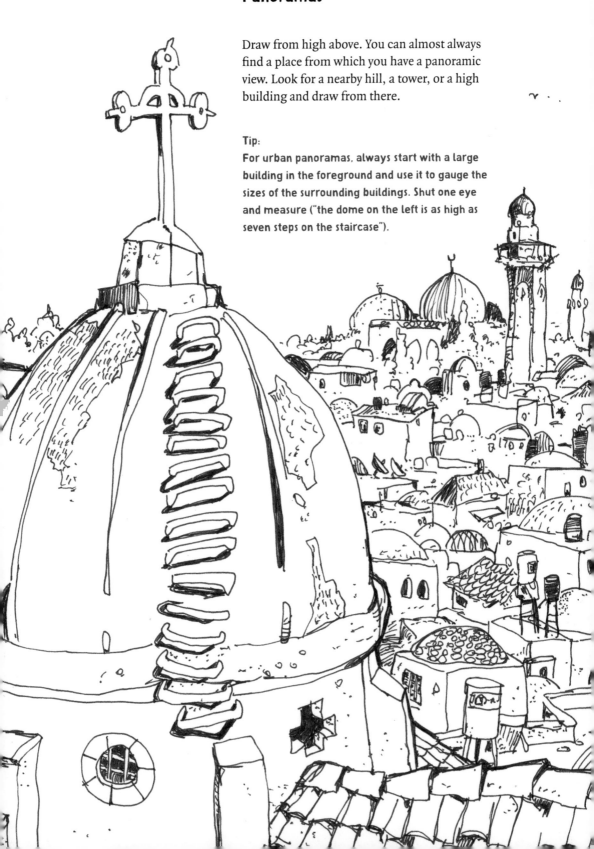

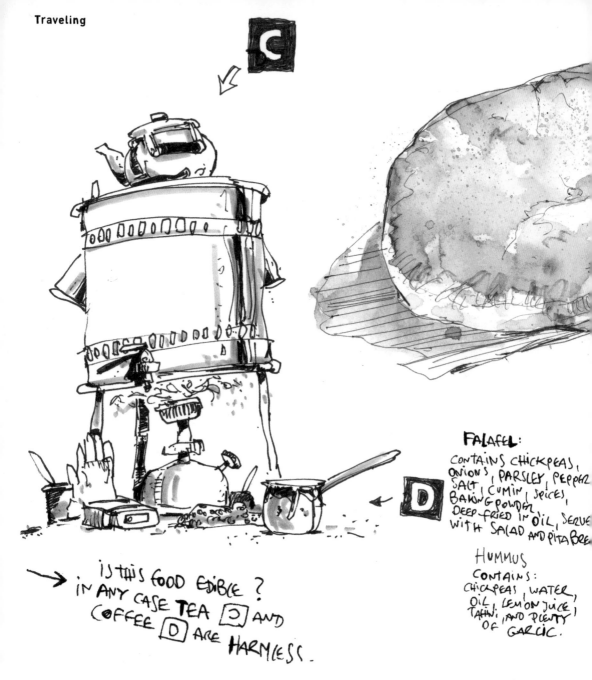

FALAFEL:
CONTAINS CHICKPEAS, ONIONS, PARSLEY, PEPPER SALT, CUMIN, SPICES, BAKING POWDER, DEEP-FRIED IN OIL, SERVE WITH SALAD AND PITA BREA

HUMMUS
CONTAINS:
CHICKPEAS, WATER, OIL, LEMON JUICE, TAHINI, AND PLENTY OF GARLIC.

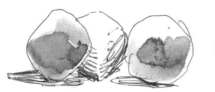

IS THIS FOOD EDIBLE? IN ANY CASE TEA ⊂ AND COFFEE ⊡ ARE HARMLESS.

CHICKPEAS

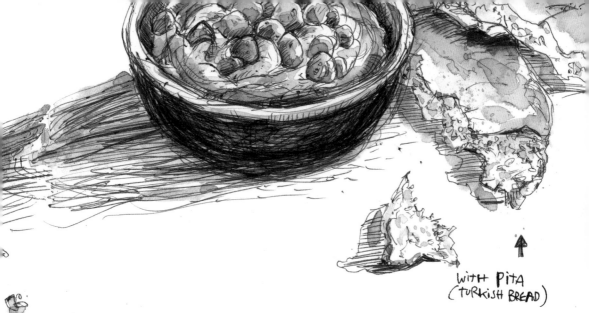

WITH PITA
(TURKISH BREAD)

Trifles and truffles

Sketchbooks are suitable for more than just big panoramas; even small details have narrative power. For example, put interesting facts about your destination country in your drawings.

It can be directions, vocabulary, or anything you encounter every day, like food. Jot down recipes and draw the ingredients and results! Everyday tools are also good subjects.

Make use of the time you spend waiting in a restaurant for your meal to draw other guests or details. If you use the opportunity to write down a few lines about the flavor of foods and beverages, you'll add another interesting level of narrative.

Fruit Presses:

A

B

A: CARROT

B: ORANGE

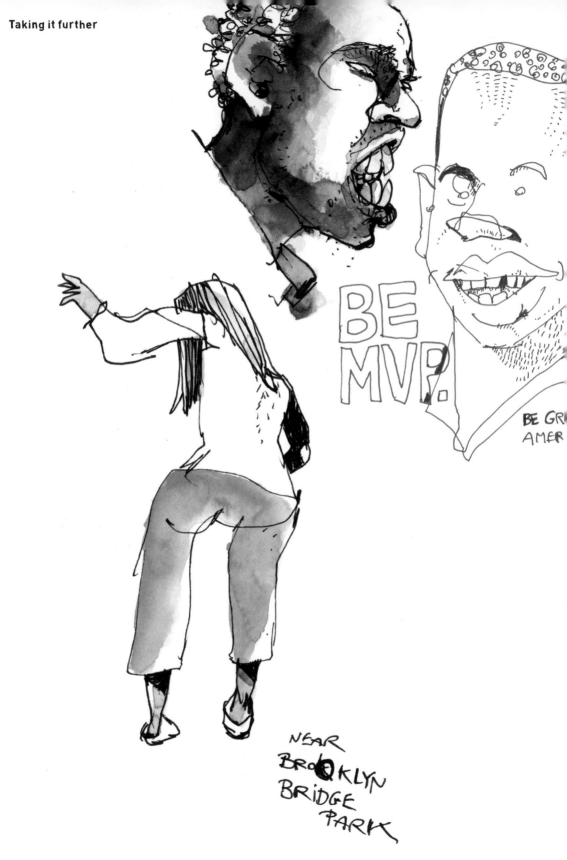

BE
MVP.

BE GR
AMER

NEAR
BROOKLYN
BRIDGE
PARK

Reality is not reality is not reality

If you are asking yourself how realistically you should portray your subject, you're skating on very thin ice.

There is not just *one* reality. There is only one's own perspective, which can be very different depending on who you are. One man's freedom fighter is the other's terrorist. "Reality" is a compromise among many ways of seeing. Hence, realistic drawing is more like the smallest common denominator than any actual reality. Instead, think about *what* you want to convey. If it is important to you to portray the tiniest details of your subject, then you ought to make an effort to be precise. If instead you want to illustrate a frame of mind or a movement, you will probably do better to draw with more expression.

Even a seemingly hyperrealistic drawing is not realistic if it does not suit the subject. Conversely, a hastily scribbled sketch can adequately render reality—information about a mood, for instance—without being objectively realistic. As contradictory as it may sound, even reality is not very realistic.

Tip:
No one is keeping you from *mixing* different perspectives in one drawing. For example, try painting everything that moves abstractly, and everything standing still realistically. You'll be amazed at the results.

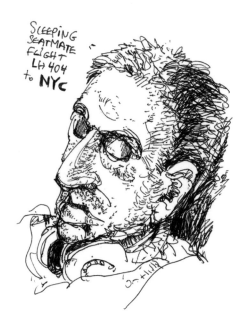

SLEEPING
SEATMATE
FLIGHT
LH 404
to NYC

DECEMBER 19th CHURCH OF THE

Everything is in flux

A sketch is not merely an illustration of reality. A sketch is a piece of time.

A moment flashes by and is gone forever: only you experienced it that way. Everything moves and nothing ever returns. The irretrievable has always frightened people and we have devised many strategies to counter it.

One way to remember something is to convey the moment to others, such as in stories or—in our case—in drawings. The special thing about a sketch is that it captures time. A drawing not only illustrates, it also documents its own genesis. While you experienced the scene, you drew it. This makes sketches precious, because you "charge" them with the moment. Later viewers are given something immediate to look at; they are given a glimpse of a moment that has passed. Even if your drawing is not perfect, it is a genuine piece of time that will never be repeated.

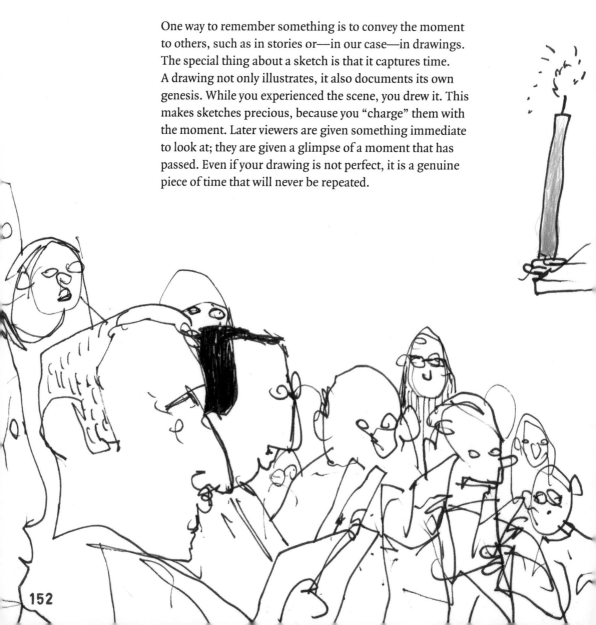

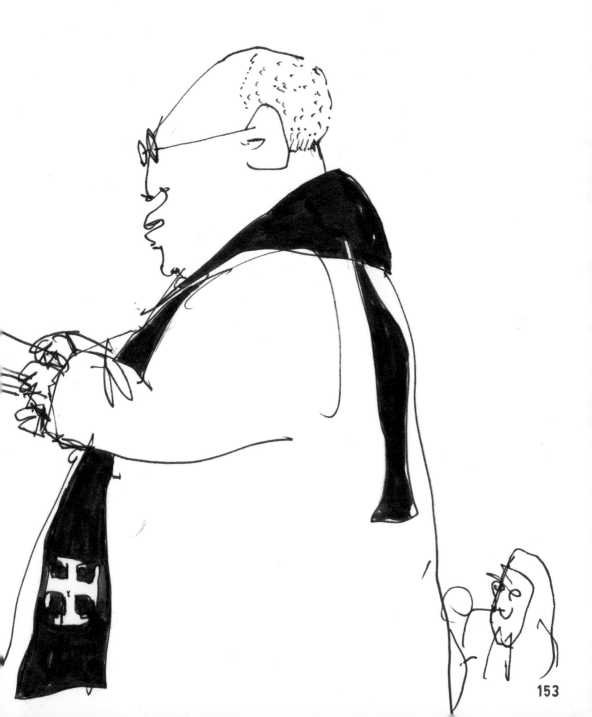

Redoing drawings

Have you ever attempted to redo one of your drawings, or to copy one? Oddly enough, it almost never works out right. With every new attempt, the same drawing becomes flatter and more tepid. It's as if you cannot reproduce the directness and spontaneity of a sketch. Even if you think you might do better on this eye or that nose the second time around, the price you pay for a better new nose is often a worse new mouth.

For this reason, the ability to process sketches on the computer is a fantastic stroke of luck. Earlier generations of illustrators had only manual re-drawing or tracing at their disposal to remove a sketch from their book (if they did not want to tear out pages).

Today, you can scan your pictures and continue processing them. You can make them part of a picture or an illustration, or blend them with other pictorial elements. This allows you to preserve the immediacy that might otherwise be lost through multiple copies. The sketch above, for example, was scanned into Photoshop and combined with two other sketches and a colored layer to produce an editorial illustration about Istanbul (shown opposite).

Yet in spite of all of these possibilities, remember that your drawing is just as unique as the moment in which you made it. So handle it carefully.

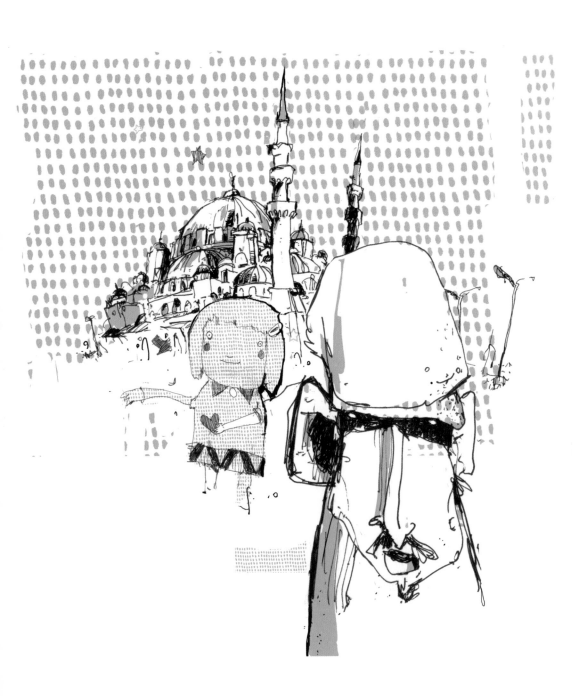

Using digital media

It is true that, in recent years, computers have supported the revival of drawing. As long as it was technically impossible to produce hyperrealistic images, it seemed incredibly desirable to attempt to do so using drawing and illustration. Consider photorealism in the 1970s or the airbrush paintings of the 1980s.

Then suddenly, with the development of fast graphic computers, it became possible to bring illusions to life. Dinosaurs and creatures of fantasy were animated. For a while there, traditional techniques seemed incredibly old-fashioned.

In the meantime, however, we have recognized that digital images often appear too "perfect," pushing the personal touch to the sidelines. The strength of drawings lies in ideas, content, and expressiveness.

It is the personal touch that makes a sketch exciting. When it takes full advantage of its actual strengths, drawing is an ideal interface to the new technologies. With computers we can edit and transform drawings to any imaginable size, color, and format. They can be serially and sequentially generated, processed into films and animations, and combined with other image media such as typography and text.

In other words, don't hesitate to further develop your sketches on the computer. The results will profit from the mix!

Whatever happened to da Vinci's sketchbook?

In closing, I would like to say a few words about all the sketchbooks that were produced in past centuries—and where they ended up.

Whatever happened to Leonardo da Vinci's sketchbook? The answer: it no longer exists. After his death, Leonardo's sketchbooks and notebooks were torn apart and scattered around the world. The only volume that was preserved, the more than one thousand–page *Codex Atlanticus*, was later re-compiled by collectors and re-bound. Today it is at the Biblioteca Ambrosiana in Milan. Many sketchbooks suffered the fate of being looted (single pages are easier to sell), although some by Dürer and Rembrandt were preserved. Beginning in the nineteenth century, sketchbooks were collected; you can still purchase facsimiles of the sketchbooks of artists like J. M. W. Turner and Caspar David Friedrich. The sketchbooks of more modern painters have also been largely preserved in one piece (if they haven't been stolen, as was recently the case with a sketchbook from Pablo Picasso in Paris . . .).

Today, many artists regularly publish their sketchbooks on the Internet. Visits to the countless blogs and sketch websites are always worthwhile. But despite all of the publication possibilities, the sketchbook still remains something intimate and personal. It remains a field of experimentation and of trial and error. It remains a notebook and a diary.

And yet, the most important of them all is your own sketchbook, and the sketchbooks to come—the sketchbook you will begin next!

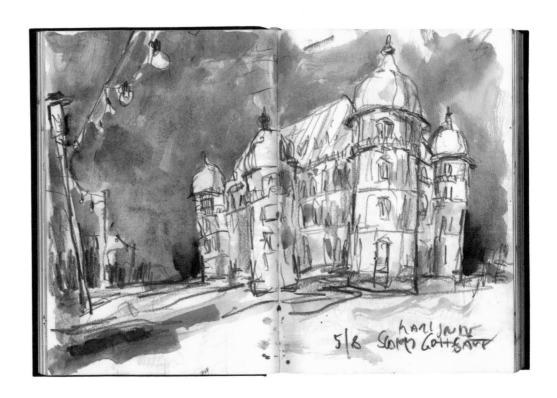

About the author

Felix Scheinberger is an illustrator, artist, and designer. He is the author and illustrator of three books on watercolor and has illustrated more than fifty books in the last decade. His work has appeared in many magazines, including *Harvard Business Manager* and *Psychology Today*. Felix is a professor at the Münster School of Design and lives in Berlin, Germany.

Also by the author

Urban Watercolor Sketching

Bring new energy to your sketches of urban scenes with this fresh and simple approach to watercolor painting. Whether you're an amateur artist, drawer, doodler, or sketcher, watercolor is a versatile sketching medium that's perfect for people on the go. Felix Scheinberger offers a solid foundation in color theory and countless lessons on all aspects of watercolor sketching. Vibrant watercolor paintings grace each page, and light-hearted anecdotes make this a lively guide to the medium.

160 pages
8¼ x 9½ inches
ISBN-13: 978-0-77043-521-9
Watson-Guptill Publications

Translation copyright © 2017 by Verlag Hermann
Schmidt Mainz
Illustrations copyright © 2009 by Felix Scheinberger
and Verlag Hermann Schmidt Mainz

Published in the United States by Watson-Guptill
Publications, an imprint of the Crown Publishing
Group, a division of Penguin Random House LLC,
New York.
www.crownpublishing.com
www.watsonguptill.com

WATSON-GUPTILL and the WG and Horse
designs are registered trademarks of
Penguin Random House LLC

Originally published in Germany as *Mut zum
Skizzenbuch* by Verlag Hermann Schmidt Mainz in
2009. This translation arranged with Verlag Hermann
Schmidt Mainz. Translation by Faith Gibson.

Library of Congress Cataloging-in-Publication Data
is on file with the publisher.

Hardcover ISBN: 978-0-399-57955-4
eBook ISBN: 978-0-399-57956-1

Printed in China

Design by Felix Scheinberger
Cover design by Ashley Lima

10 9 8 7 6 5 4 3 2 1

First American Edition